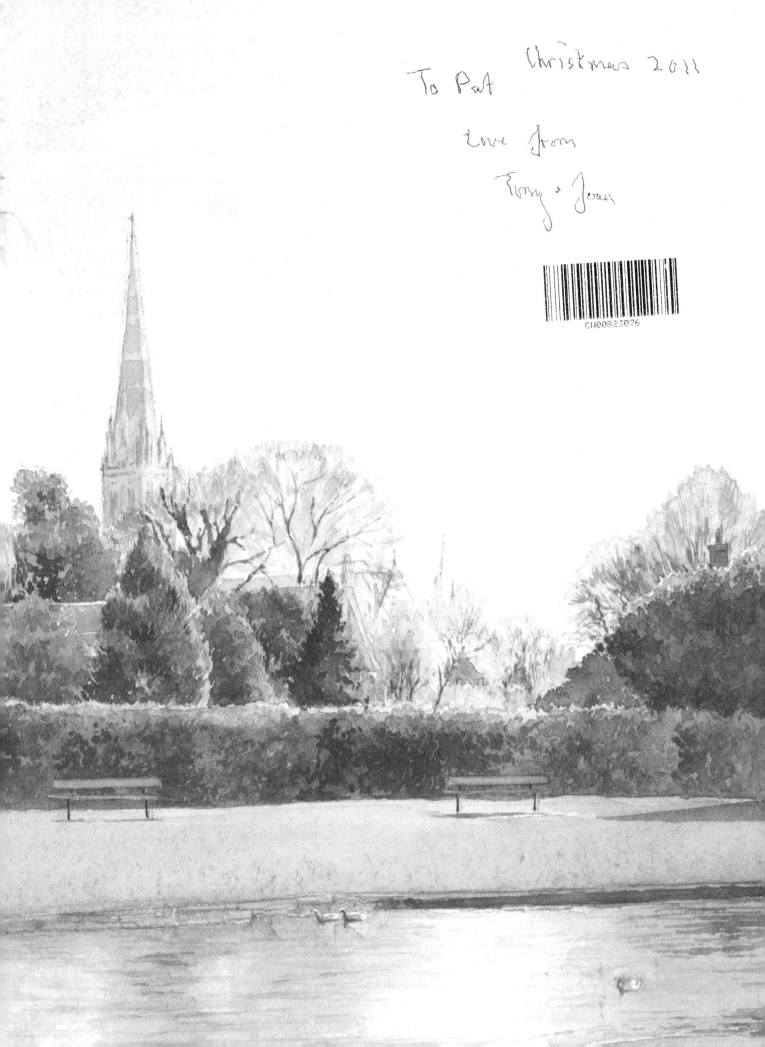

To Pat

Christmas 2011

Love from

Tony & Joan

Salisbury
A Walk in the City

Salisbury
A Walk in the City

Sue Finniss

with architectural descriptions by

John Elliott

Spire Books Ltd

PO Box 2336, Reading RG4 5WJ
www.spirebooks.com

Spire Books Ltd
PO Box 2336, Reading RG4 5WJ
www.spirebooks.com

CIP data: A catalogue record for this book is available from the British Library
ISBN 978-1-904965-28-2

Grateful thanks to Ruth Newman for advice and guidance

Jacket front: The High Street looking north towards St Thomas's church
Rear: Prezzo at the other end of the High Street just before the entrance to the Close.

CONTENTS

A walk in the city

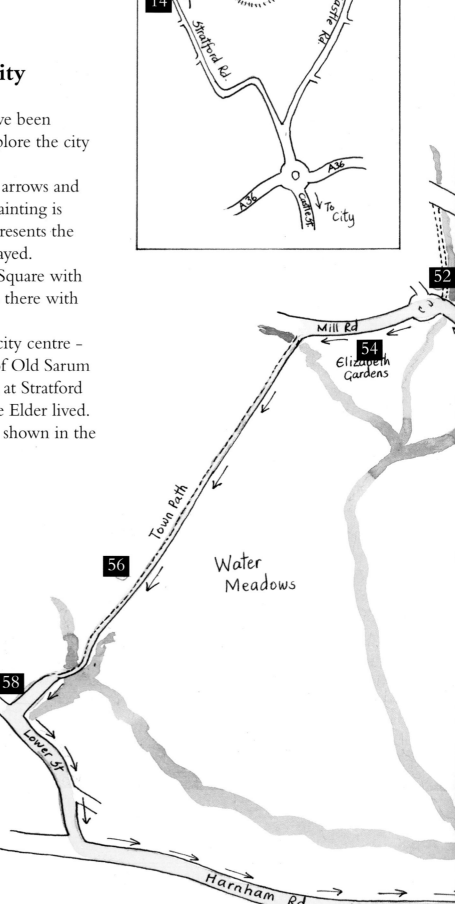

The paintings in this book have been arranged so that you can explore the city through a circular walk.

The map shows the walk with arrows and a yellow route. The subject of a painting is indicated by a number which represents the page number on which it is displayed.

The walk starts in the Market Square with the painting on page 10 and ends there with that on page 84.

Two paintings fall outside the city centre - those on pages 12 and 14 - one of Old Sarum and another of Mawarden Court, at Stratford sub Castle, where William Pitt the Elder lived. The location of these paintings is shown in the inset.

Route

Pedestrian area

Market Square
(start and finish)

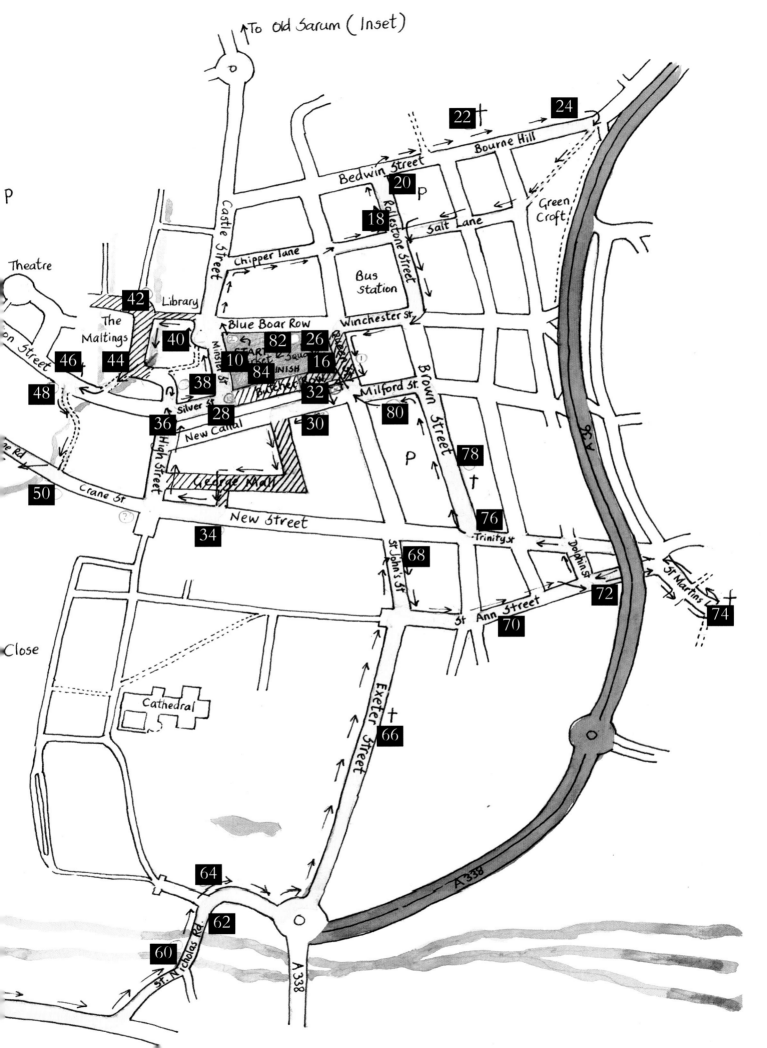

Artist's preface

Being born and bred in Salisbury, I am very proud of my home city and become defensive of it in the face of any criticism. Sadly the individuality of many cities is rapidly disappearing behind the façades of multinational retailers and companies so, in this book, I aim to celebrate the special quality of Salisbury in the hope that it will never be lost.

The most significant feature of Salisbury is, of course, the cathedral and the Close that surrounds it. In this book, however, the cathedral does not feature very much because it was the subject of my previous book *Salisbury: A Walk in the Close*. Instead I have chosen a selection of buildings in the city that are significant to me, either for their architectural or historical interest, their importance as gathering places for Salisbury residents or, simply, because I think that they are attractive buildings. The result is an eclectic mix of churches, almshouses, streets and public houses.

I am aware that there are many more significant buildings that have not been included and stress that this book represents purely my personal choice of subjects for a work of this scale. I apologise to those who feel disappointed by my omissions.

Of course, no book about Salisbury would be complete without reference to Old Sarum so I have included a painting of this and the house in the village of Stratford sub Castle where William Pitt spent some of his childhood, although they are out of the area that encompasses *Salisbury: A Walk in the City*.

I am immensely grateful to John Elliott who volunteered his expertise in the preparation of the architectural and historical notes that accompany the paintings and which add a further dimension to the book. I would also like to thank John and his colleagues at Spire Books for their support and professionalism.

Sue Finniss
September 2010

Opposite: Behind the horses we see what proclaims to be John À Port's House, a half-timbered building that matches what most people think a medieval house should look like. In fact John À Port lived elsewhere in the city. The house dates from *c.*1450.

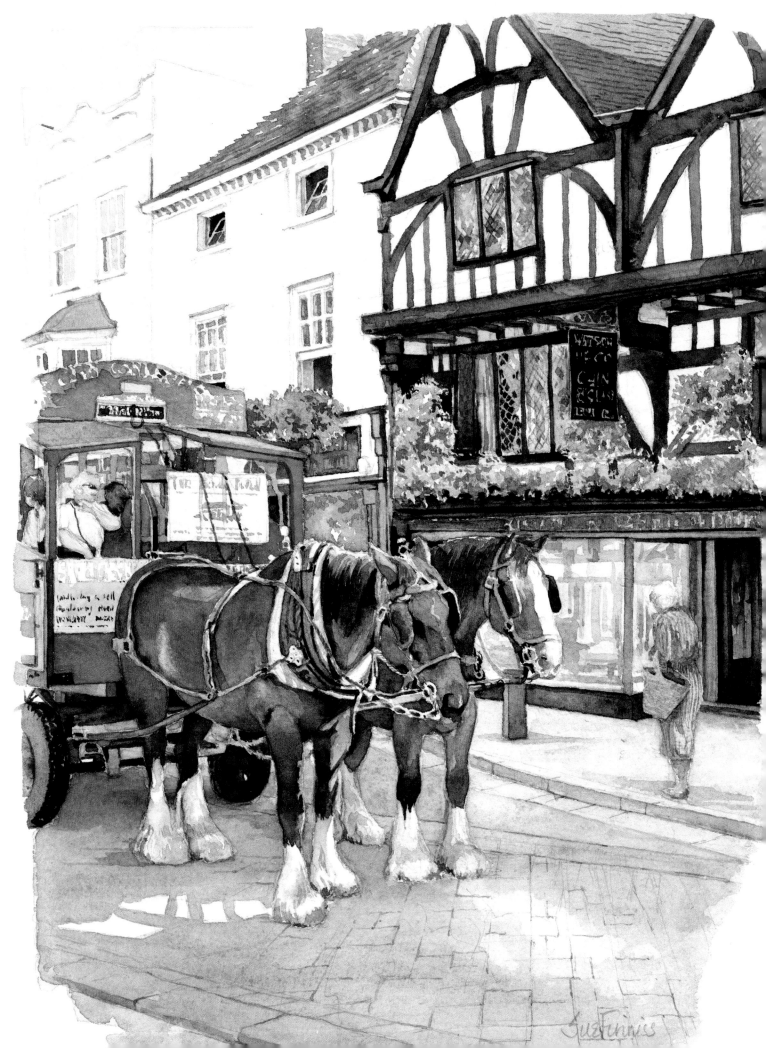

Introduction

The origins of Salisbury are not in the current city but two miles north, at Old Sarum, a Roman settlement and an Iron Age hill-fort, before the Normans made it a major castle site. A cathedral was built here after 1075, completed by Bishop Osmund (bishop 1078-99) and consecrated in 1092 sharing the site with what was a strongly defended royal settlement which formed a major trading centre. The cathedral was extended and rebuilt under Bishop Roger (bishop 1102-39). Then in 1219 plans by Richard Poore (bishop 1217-25), to move the cathedral to a completely fresh site in the valley below were approved and the foundations of the current cathedral were laid in 1220.

No sooner had work started on the cathedral, than plans were afoot for a new city - New Sarum - to accompany it. The centre was the Market Square and from around this a planned town, laid out in a series of 'chequers' was developed. With time the city expanded to the north with the addition of the area around St Edmund's church. In the nineteenth century, boundaries extended as Fisherton, on the western side, expanded with the arrival of the railways. Exeter Street was developed to the south while Milford, to the east emerged as a suburb where the leisured classes could live. Even later - in the twentieth century - there has been very rapid expansion to the north and the north-west, and Salisbury has become all but connected with Harnham to the south-west.

Yet despite this expansion Salsibury does not sprawl like so many other large towns and cities. Perhaps this is because of the rather unusual pattern of land holding which exists. Much of the land to the east of the river Avon is owned by the Radnor Estate while much of that to the west is held by the Pembrokes. Many of the farms are run by tenant farmers of these big estates. As a result land to build on is hard to locate.

However, the early economic fortunes of Salisbury were not completely controlled by the merchant classes who moved to the city and made it one of the busiest and richest in England. Instead it remained partly under the authority of the bishop until 1612 when the city gained a new charter which freed the corporation from the bishop's control. Slowly but surely the city took on a separate secular existence while the cathedral tended to restrict its activities and influence to within the Close walls. Today Salisbury is a prosperous market town which supports a number of large companies - the biggest being Friends Provident - and the adjacent army presence on the Plain.

Much of Salisbury's early wealth depended upon its links with the adjoining agricultural areas, the abundant supply of water to power the fulling mills and the easy transport links between it and the port of Southampton which acted as a gateway for raw materials and finished products. When Daniel Defoe undertook his great tour of the British Isles in the 1720s he described Salisbury as a 'large and pleasant city' inhabited by people who were 'gay and rich'. Its economy was dominated by the manufacture of 'fine flannels, and long cloths'. In the nineteenth century Salisbury was overtaken by other cities and towns which experienced the effects of the Industrial Revolution while Salisbury settled into the role of a comfortable market town. Today there is a vibrant local economy, and the city is home to commuters who find it a pleasant place to live while working elsewhere. Salisbury Cathedral and the city are also major international tourist attractions.

Many books have been written on the city and its evolution, the principal of which is John Chandler's *Endless Street* (1983) which is now out of print but often available secondhand. For the architecturally minded there is an excellent volume by the Royal Commission on Historical Monuments in England on the *City of Salisbury* (1980), the very readable *Salisbury Past* (2001) by Ruth Newman and Jane Howells, and the challenging *Time, Space and Order: The Making of Medieval Salisbury* (2009) by Christian Frost who links the planning of Salisbury with the liturgy which dominated thirteenth-century cathedral life.

The view opposite is typical of the city centre and shows the north-west corner of the Market Square and a variety of buildings of different ages. On the left there is the northern end of Oatmeal Row with its range of ornate late-Victorian buildings. Then in the centre there is a group of buildings in Blue Boar Row on the north side of the Market Square. These are mostly from the nineteenth century but try hard to appear much older.

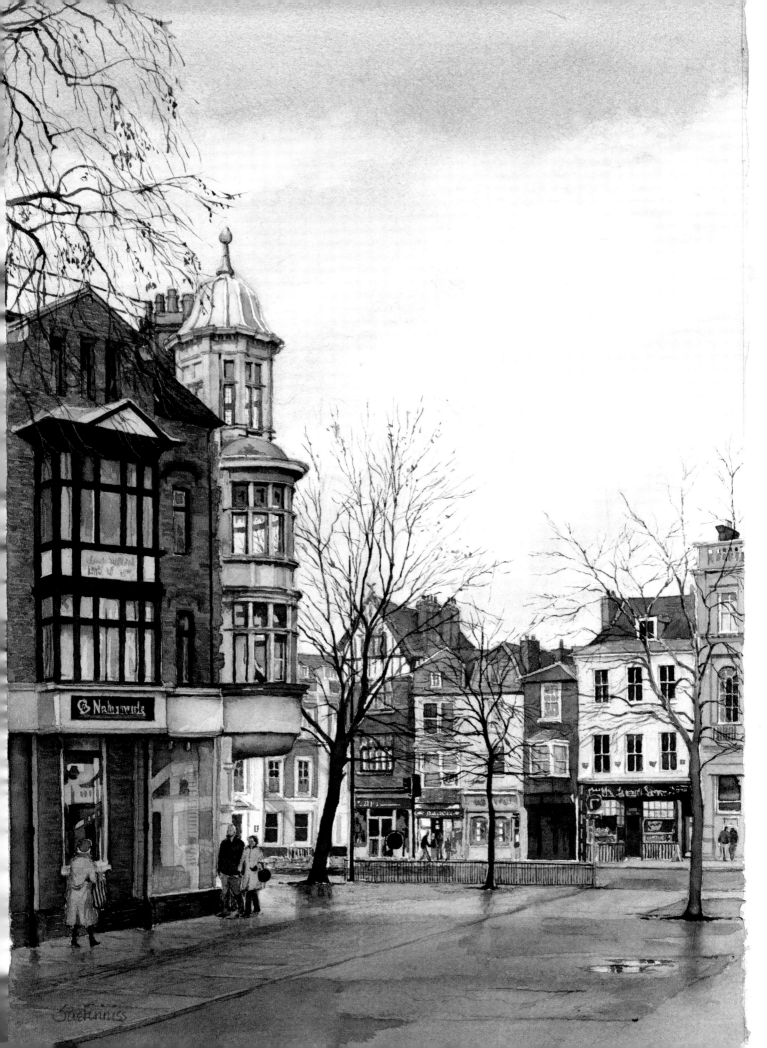

Old Sarum

The story of Salisbury starts in Sherborne, a small Dorset town some 35 miles to the west. It was here in 705 that the King of Wessex created a bishopric to cover the western part of his kingdom. Aldhelm was made bishop and the new see was centred on the monastic complex there.

The cathedral at Sherborne is long gone. The eastern part of the diocese was separated off in 909. Then in 1075 the king directed that henceforth all cathedrals should be located in fortified towns and the diocese was moved to the hill of Sarisberie, or Old Sarum as we know it.

Old Sarum had been an Iron Age hill-fort before being occupied by the Normans as a military centre. It was also probably a Roman settlement. A network of Roman roads converges on the site.

After the see was transferred from Sherborne in 1075-8, Bishop Herman and later Bishop Osmund started building a cathedral and castle at Old Sarum. The cathedral was 173ft (53m) long and consecrated in 1092. Bishop Roger enlarged and extended both the cathedral and the castle between 1107 and 1139 before falling out with the king and losing the castle. The enlarged cathedral was about 316ft (96m) long and had a western façade with towers. Bishop Roger also added a cloister and there was a chapter house and bishop's palace.

By about 1200 relations with the military were poor. The site - as today - was very exposed, and there was a continual shortage of water. A plan was made to move the whole cathedral establishment to a new site in the valley south of Old Sarum and to build a new, magnificent cathedral there. It seems likely that plans for this were afoot as early as 1198-9. The Pope gave his permission in 1218 and the foundation stones of the new cathedral were laid in 1220. Almost straightaway work started on redeveloping the settlements which existed in the valley, and on the creation of a new town - New Sarum or Salisbury.

We do not know whether those who planned the move knew quite what a master-stroke it would be: one which was to lead to the creation of one of the greatest cathedrals in Britain, the largest cathedral close in the country and a new purpose-built city which would quickly eclipse Old Sarum. The bishop had moved from being a tenant on the hilltop to being a landlord in New Sarum - a stroke of economic genius.

The castle at Old Sarum remained, and much money was spent on it in the 1240s. However, such an isolated hill-fort had no long-term future and by 1535 it was in ruins, as was the cathedral which had just a chapel to Our Lady remaining. Much of the stone used to build the cathedral complex at Old Sarum was transported down the hill and is clearly in evidence in the new cathedral Close wall which was erected after 1327.

Mawarden Court

Located in the village of Stratford sub Castle slightly to the north of Salisbury and close to Old Sarum. Mawarden Court, an attractive, much altered Jacobean house is important because William Pitt the elder lived here for a time.

Before its abolition under the Reform Act of 1832, Old Sarum was notorious as a rotten borough where a handful of wealthy people controlled the election of two MPs who would serve the constituency.

From the seventeenth century it had no resident voters as the population had migrated to New Sarum. However, whoever owned the land retained the right to nominate tenants for each of the burgages which existed and these people were not required to live in the constituency but *were* entitled to vote.

At one time the borough was owned by the Pitt family and William Pitt (1708-78) - often known as Pitt the Elder to distinguish him from his son who was also called William (1759-1806) - was the MP from 1735 to 1747. In fact William Pitt's brother stood as the candidate for both Okehampton and Old Sarum in 1734 and won both. He elected to sit for Okehampton and the Old Sarum seat passed to William in 1735. Pitt, later Earl of Chatham, went on to be Prime Minister from 1766 to 1768.

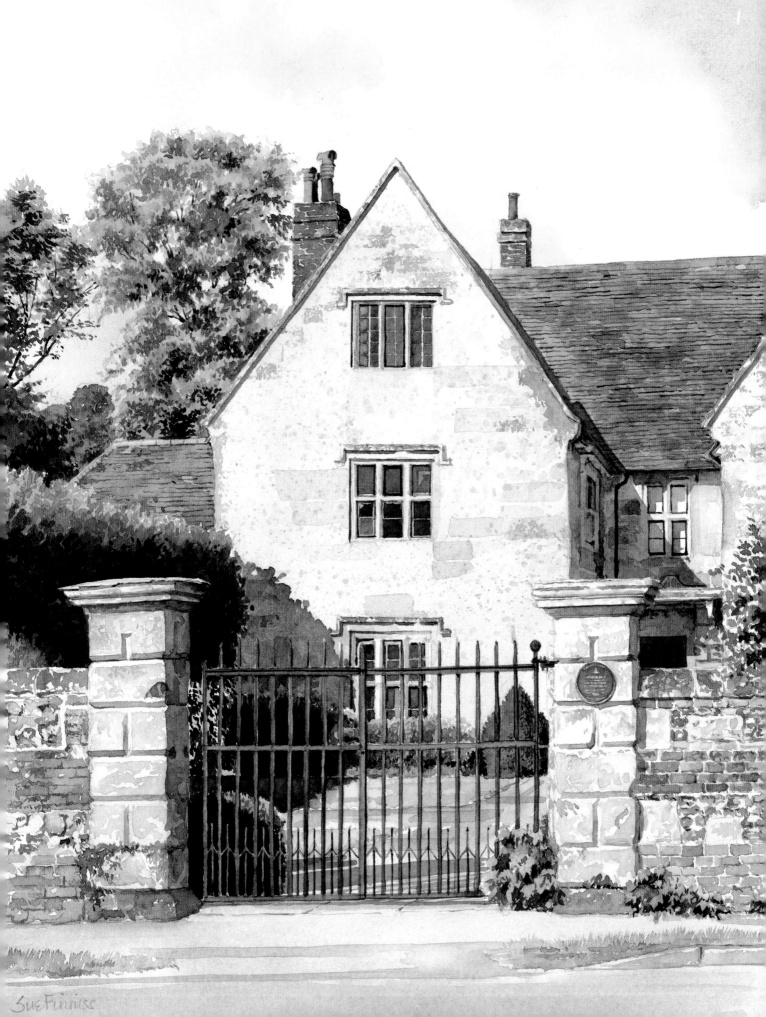

Sue Finniss

Market Square

This view looks towards the east with Cross Keys House on the left in the background. The market is held on Tuesdays and Saturdays.

The Market Square represents the commercial centre of Salisbury. A Friday market was started here as early as 1219 to serve those laying out and planning the new settlement, but the Tuesday market dates from 1227 with Henry III's (king 1216-72)charter to the city. An August Fair was started in 1221, then an October Fair in 1270, while a Saturday market and Lady Day Fair were permitted in 1315. However, unauthorised markets were held somewhere in Salisbury on most days and this led to complaints from the surrounding towns. In 1361 the markets were restricted to just Tuesday and Saturday.

The original Market Square was much bigger than the current one and stretched north/south from Blue Boar Row to New Canal and east/west from Queen Street to the river Avon. The land currently occupied by the 'rows' on the southern side of the square, plus that occupied by the buildings which lie between the Market Square and the river, was originally the site of temporary stalls. These were later replaced by permanent buildings.

Salisbury was always a prosperous city. It acted as the focus for the surrounding agricultural lands, and the abundant supply of water provided by its five rivers enabled it to specialise in the cloth industry. Around 1400 the population of Salisbury was about 5,000, about half of whom were connected with the cloth trade; leather work and food and drink occupied much of the remainder.

At this time the western and southern sides of the Market Square would have been dominated by the sale of food. Corn was traded in the north-west corner and the stocks and whipping post were on the northern side. The north-western corner of the square is still known as the Cheesemarket.

Today the markets still flourish on Tuesdays and Saturdays and the Market Square is used for large public events, though sadly, for much of the remainder of the time it has become yet another car park!

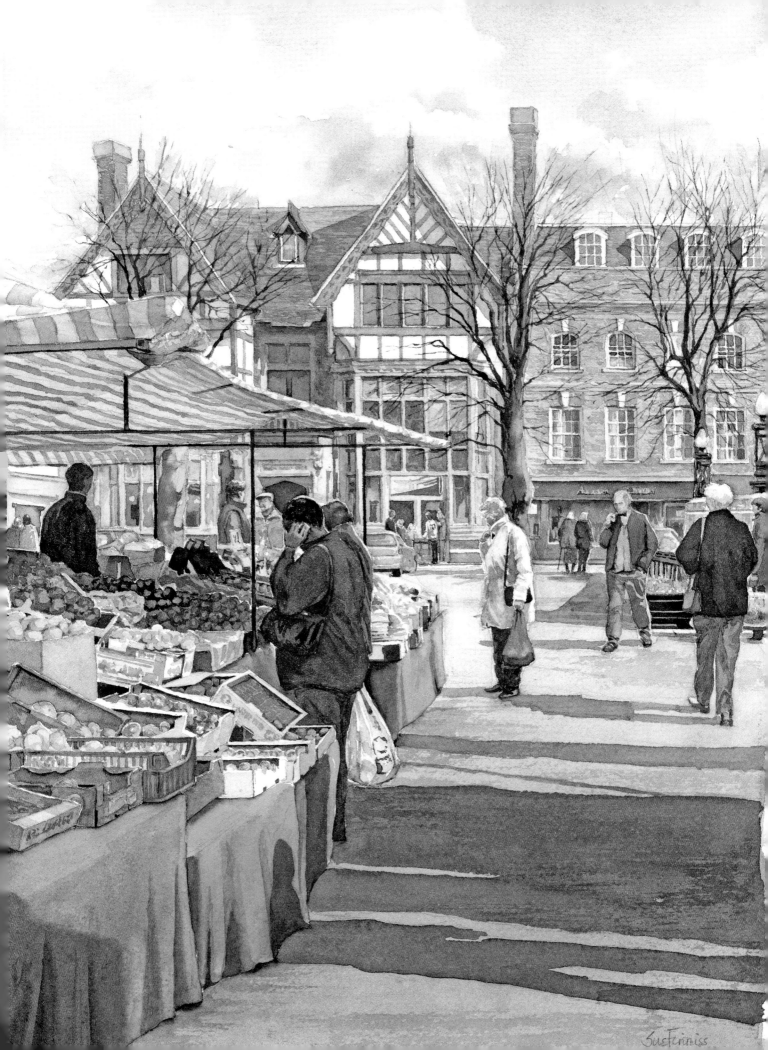

Pheasant Inn

Located on the corner of Salt Lane and Rollestone Street, opposite the south-western corner of the Salt Lane car park.

The building which abuts the road probably dates from the fifteenth century. Then in 1638 a schoolmaster, Philip Crew, gave it and the adjoining land to the Shoemakers' Company, and suggested that they create a guildhall. A large seventeenth-century Shoemakers' Hall was then erected behind the original façade on the north-west corner of the site. You enter through the archway off of Salt Lane.

The lower walls have been rebuilt in brick, though elsewhere much of the original survives, including some of the internal woodwork.

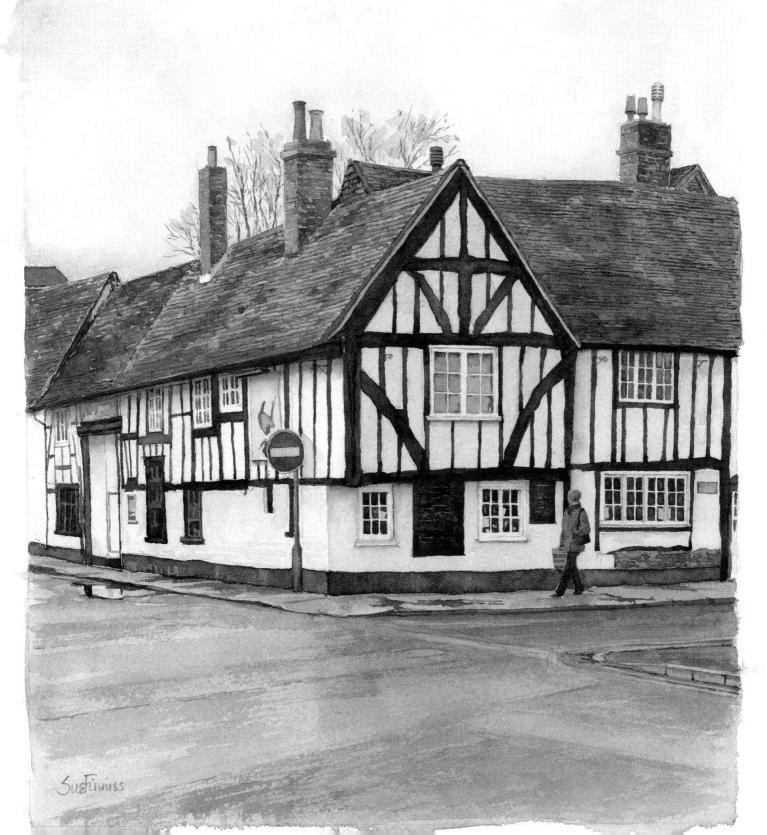

SueFinniss

Frowd's Almshouses

Located between Salt Lane and St Edmund's (Salisbury Arts Centre) in the northern part of the city centre.

There are several almshouses in Salisbury. Frowd's Almshouses have a front elevation on Bedwin Street while the rear elevation opens onto a courtyard and is the subject of this painting.

These almshouses were built in 1750 to accommodate 24 pensioners and were paid for by Edward Frowd, a city merchant. The whole is of brick below a tiled roof and is topped with a lantern. The rear elevation comprises no less than seventeen bays each of which has a delightful circular window on the upper floor as shown here.

In 1974 the building was much altered and converted for use as a hostel.

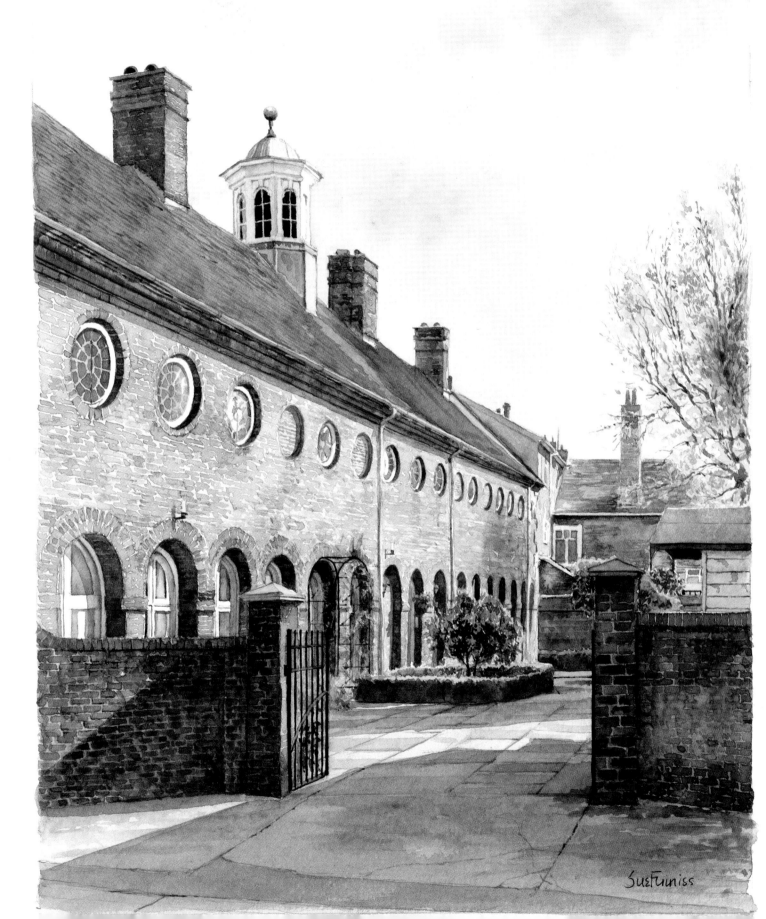

SueFurniss

St Edmund's from the Greencroft

St Edmund's, or the Salisbury Arts Centre as it now is, and the Greencroft are both located in the north-east corner of the city.

As the medieval city expanded outwards to the north and east, so an additional church was needed for the people who inhabited this area. Building work started on St Edmund's church in 1264 and a parish existed by 1269. The church was part of a larger religious complex with a permanent body of clergy who lived in an adjacent college to the east of the church.

What remains today formed the chancel and eastern end of the original church which was about double the size of the present structure. The western end was demolished after the tower collapsed in 1653. The present tower was rebuilt in 1653-5, and the remainder heavily restored by G.G. Scott in 1865-7.

The church became redundant in 1973 and after a period of uncertainty found a new life as the Salisbury Arts Centre and was recently restored by Michael Drury.

Today the adjacent Greencroft on the south-east provides an open space within the city, though its past usage has been more varied. It was used as a plague burial site; part of the Michaelmas Fair was held here after 1570; and it was one of the places where executions took place during the seventeenth century.

The house on the corner of Greencroft Street and Bedwin Street dates from the eighteenth century.

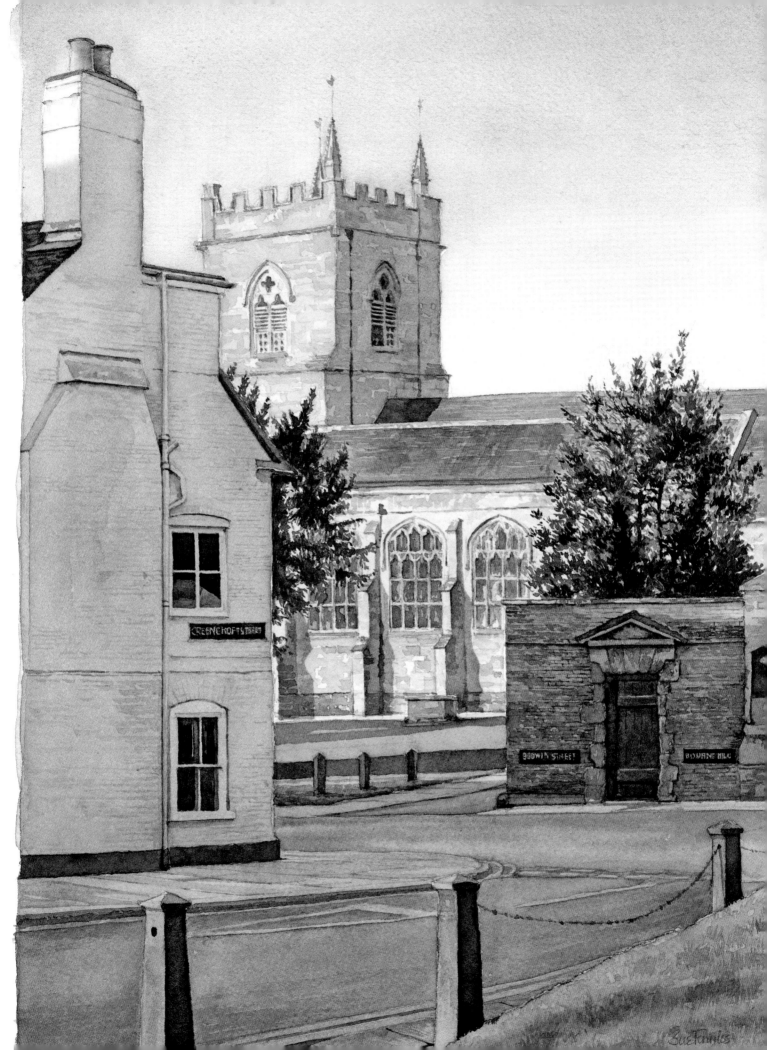

CRESNCROFT STREET

GODWIN STREET

BOURNE HILL

Sue Tinnes

A ruined porch

Painted by Turner and known as 'the ancient porch in Mr Wyndham's garden'.

Few spot this interesting ruin in the grounds of the College, or the Council House as it became known, on Bourne Hill, and even fewer have any idea how it came to be there or where it came from.

Most of the structure is from the fifteenth century and was a porch which stood outside the north transept of the cathedral. It was removed by the architect James Wyatt (1746–1813) in 1791, when he reordered the Close and transferred it to Henry Penruddocke Wyndham's house, the College, to act as a picturesque garden ornament. The short spire was added at this stage along with some pinnacles which are missing.

The open space near this structure was part of the gardens of Wyndham's house which abutted the old city ramparts. A house has stood on this site since 1269, when the College of St Edmund was formed as part of the church complex. After the Reformation it passed into secular hands and the current house was built around 1600 and then altered substantially in the eighteenth century. Eventually it passed into the ownership of Salisbury District Council who planned to extend it considerably. The work was undertaken after some fierce local debate, though by the time it was completed a Government reorganisation meant that Salisbury District Council was dissolved and Salisbury's affairs became the responsibility of the much larger Wiltshire Council.

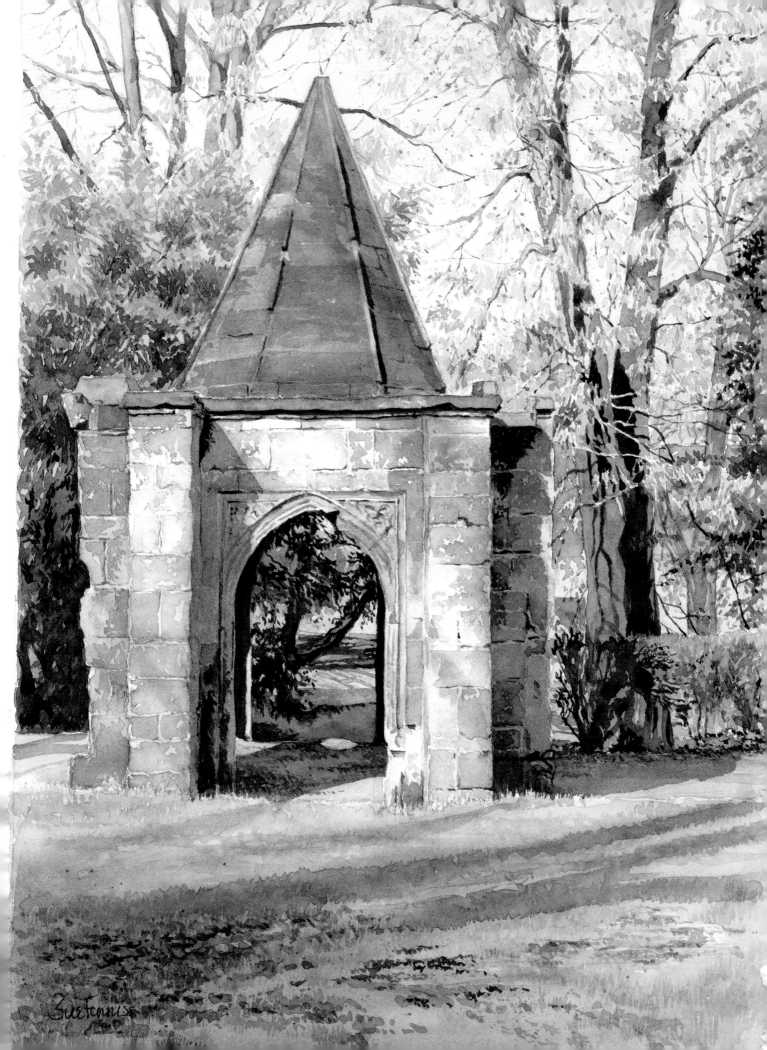

The Guildhall

This is located on the south-east corner of the Market Square and previously was a symbol of secular government and power in the city.

New Sarum was dominated by the cathedral and by the bishop. This was the bishop's city as it was built on land that he owned. With time this claim to authority was challenged by a growing city-based economy and, with it, a secular confidence which ultimately wanted to wrest control from the bishop. By about 1249 the city had a mayor, though it was not until a charter of incorporation was gained in 1612 that the break with the bishop finally happened.

In the fourteenth century a Bishop's Guildhall was built on the site of the present Guildhall to provide governance for the increasing economic activity. A medieval Council House stood on the corner of St Thomas's churchyard, but this was replaced between 1579 and 1584 by a larger structure - an Elizabethan Council House - built adjacent to the Bishop's Guildhall (on the site of the present War Memorial).

A fire in this Council House in 1780 damaged the building and provided the excuse for the citizens to rid themselves of both the Bishop's Guildhall and the Elizabethan Council House, and to build a new Guildhall that would symbolise the prosperous and self-confident secular society which now existed independent of the cathedral.

The current Guildhall, funded by Lord Radnor, was built between 1788-95, designed by Sir Robert Taylor (1714-88) and completed by William Pilkington (1758-1848). It was further modified by Thomas Hopper (1776-1856) in 1829-30.

As originally built, there was a portico on the western side, though this was removed when cells were added in 1889. Initially the central northern façade was recessed and the columns formed a screen in front. This was altered in 1829-30 to what we see today.

The Guildhall contained a council chamber, courts and cells and also a banqueting hall. The council chamber ceased to be used as such in 1927, though the courts continued to operate from there until 2009. The building was renovated in 2010 and will continue to act as a cultural and civic focus for the city.

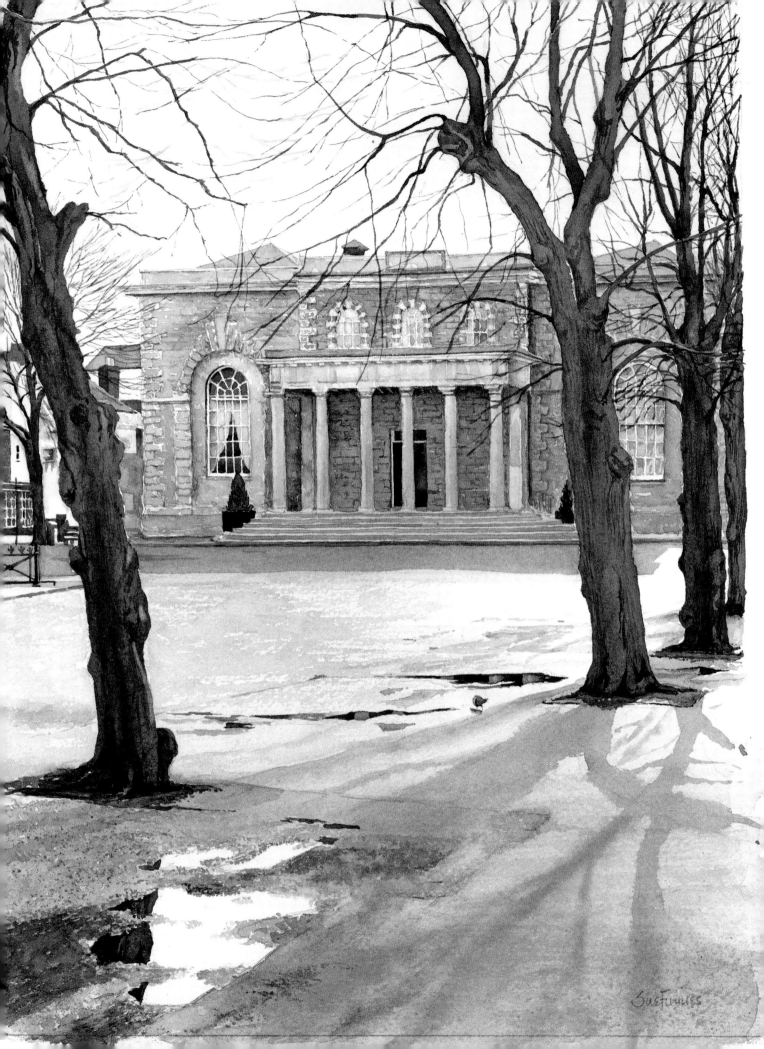

Butcher Row

This painting looks east along Butcher Row which is located beyond the south side of the Market Square, between it and New Canal.

The land now known as Butcher Row and Fish Row was originally part of the Market Square. The butchers and fishmongers worked from stalls in these areas but permanent buildings started to replace these from around 1300. The name Butcher Row was first used in 1380, but only applied to the south side of the street, the northern side being known as *la potrewe* and later *Bothelrewe*.

At the end of the street you can see the half-timbered house that is claimed to be the house of John À Port who was mayor in 1446. The house on the right is mostly an eighteenth-century rebuild. Out of sight, the house on the left is one of the oldest in Salisbury. It dates from the very early fourteenth century (1306–14) and much of the internal timberwork survives. Its façade fronting the street was 'remodelled' in the eighteenth century when mathematical tiles were applied to make the house look up-to-date. These are flat tiles which are shaped like the face of a brick. Timber battens were applied to the medieval façade and then the tiles fixed to them. In not many hours, and at moderate cost, a medieval building could be made to look as if it were a modern one.

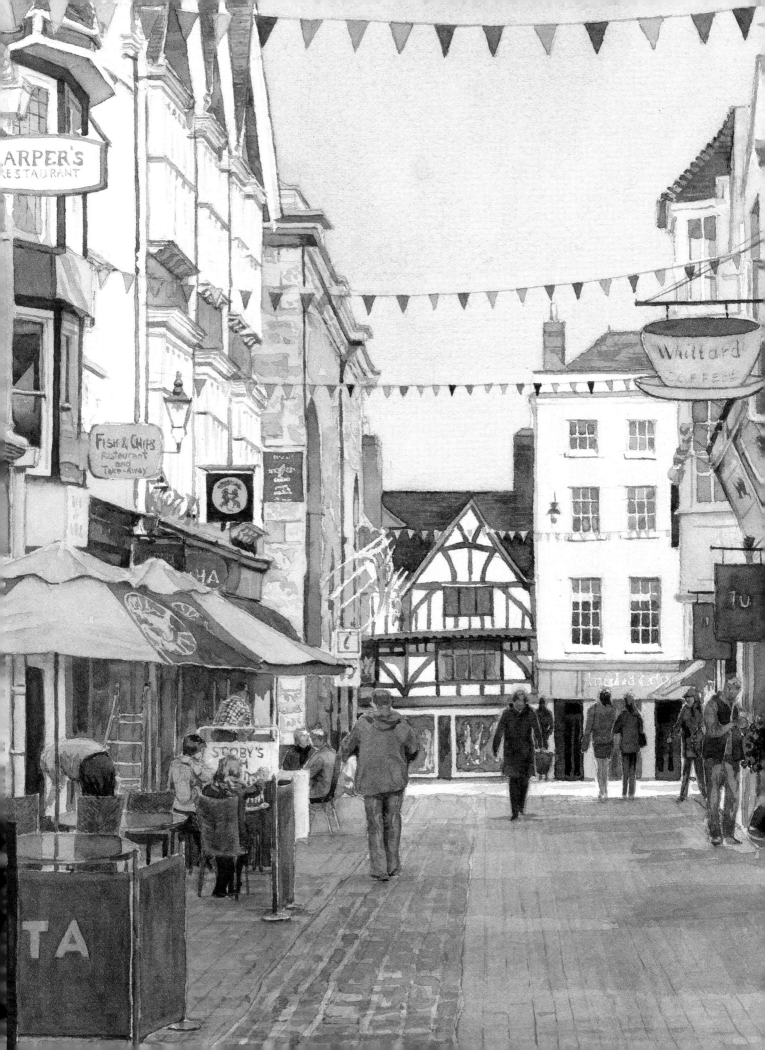

John Halle's House

Located on the south side of New Canal, right in the centre of the city.

This perhaps meets most people's ideas of what a medieval building should look like, though the façade is in fact Victorian, having been built to the designs of local Salisbury architect Fred Bath (1847-1919) in 1881. However, behind this façade we have a medieval hall which was part of John Halle's house.

Halle was a prosperous wool merchant and became mayor of the city four times. Most of the big merchants had houses that were gathered around the original Market Square.

John Halle bought the land in 1467 and the house was built between 1470 and 1483. Though much of this has disappeared, the banqueting hall has survived and was restored by A.W.N. Pugin (1812-52) in 1834, after which Fred Bath added the spectacular façade.

Today the building is a cinema. From the entrance foyer you will come to the medieval hall before reaching the cinema.

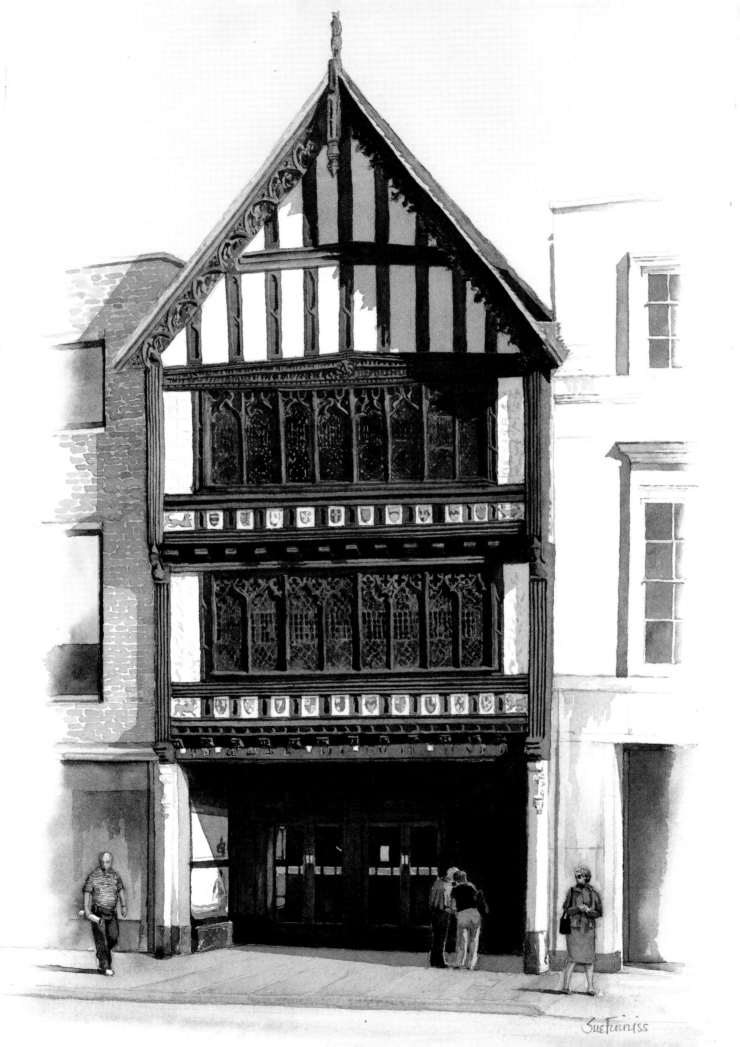

Sue Finniss

Steam Printing Works

This building is also located on New Canal, almost opposite John Halle's House.

The building at the right-hand end of the range in this view comprises two earlier structures. The larger of these is timber-framed and from the seventeenth century, but was tile-hung in the nineteenth century and subsequently rendered. The smaller, partly set-back house was built around 1780.

The building in the centre, the Steam Printing Works, was home to the *Wilts County Mirror* and the *South Wilts Express* which merged in 1887. The *Wiltshire County Mirror* was first published on 10 February 1852 whereas the *South Wilts Express* first appeared in 1871 as the successor to the *Salisbury Standard & Wilts Advertiser* which was published weekly and comprised just four pages of text. The merged *South Wilts Express* became the *Wilts News* in 1911 and the *Wiltshire Times* in 1962.

The Steam Printing Works dates from about 1870–80 and was where the steam-driven presses were located prior to the arrival of electricity.

The timber-framed building on the left is a refacing of an earlier structure. The top floor is probably Victorian pretending to be medieval, while the brick-faced first floor is probably Georgian. The shop-front is modern and undistinguished.

All three of these buildings sit on what was part of the Market Square and back onto Fish Row.

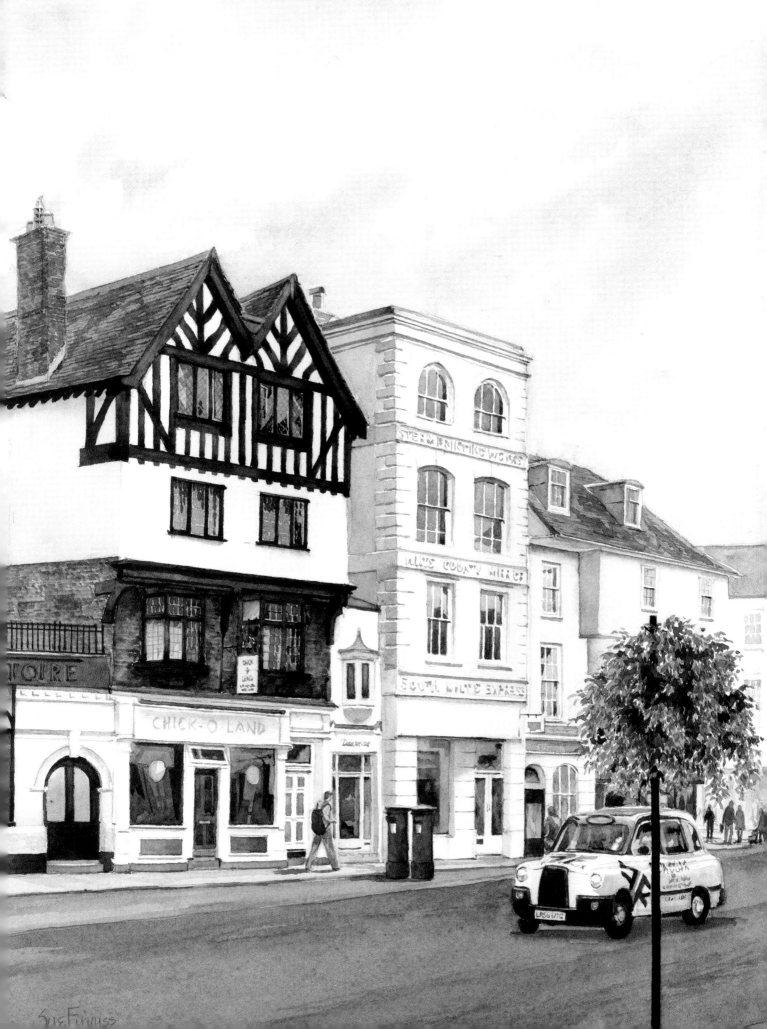

New Inn

The picturesque New Inn is located on the south side of New Street and backs onto the cathedral wall.

The jettied-out part of the New Inn gives a glimpse of what the original New Sarum would have looked like.

However, its origins are rather later. It was probably built in the late fifteenth or early sixteenth centuries with an additional wing being added on the south-west corner in the late eighteenth century.

It is of two storeys, with timber framing and the New Street façade is jettied out. The three-bay front suggests that at one time the building was subdivided into three separate dwellings, but it seems unlikely that this was the original arrangement.

The south-west wing, which is out if view in this picture, provides something of a contrast in style.

The garden at the rear of the building backs onto the Close wall.

While much of the inside continues to exhibit the building's medieval origins the rear façade has been considerably altered and is now largely obliterated by later building and tile hangings.

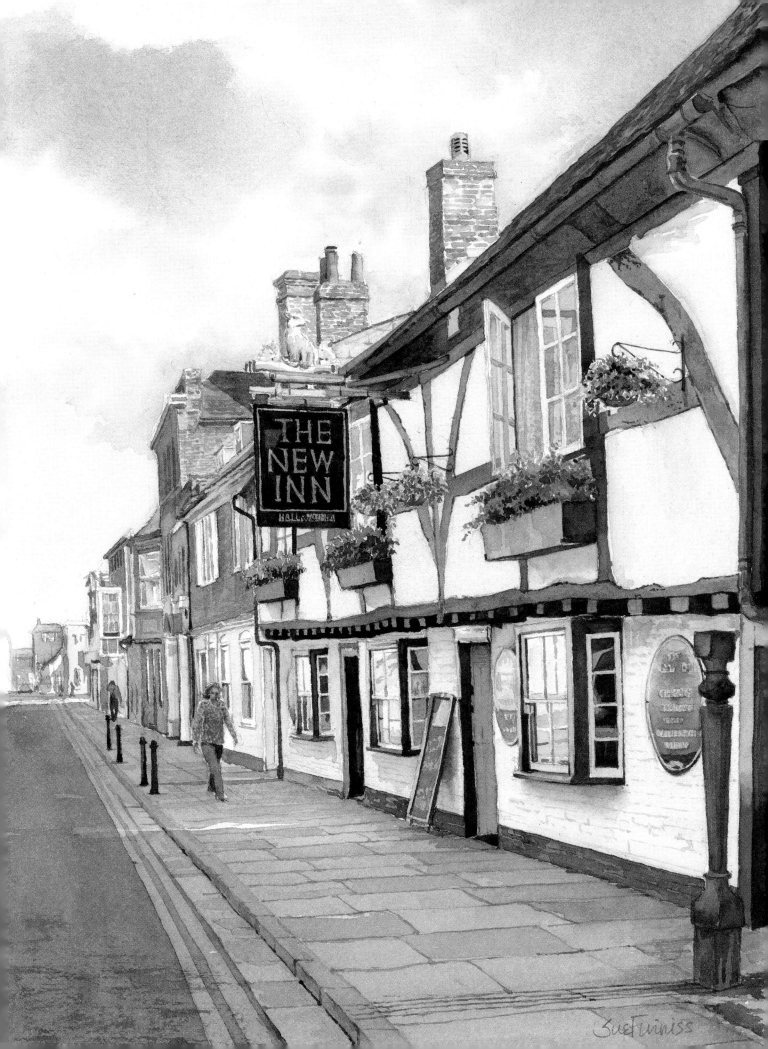

THE
NEW
INN

Sue Finniss

High Street

This view looks north towards St Thomas's church. The North Gate into the cathedral Close is to the south.

The High Street was laid out when the cathedral was built and connects the cathedral Close to the south with the city and provides a route to Old Sarum. In the medieval period this would have been one of the main thoroughfares. To the north there is the Market Square which was the economic heart of the city and St Thomas's church which was the parish church of the city and its merchants. Today the High Street is less central to economic life and its pedestrianisation has given it a relaxed feel.

In the centre of the painting there are the former Assembly Rooms with a bell-turret above. The building, which dates from 1802, staged concerts, plays and fashionable dances, and evidences an attempt to provide an alternative meeting place to the numerous pubs. It was here that Rosemary Squires sang early in her career. Today the building is occupied by Waterstone's.

On the right of the painting you can see part of what remains of the Old George Hotel. This was one of the city's coaching inns and it stretched back to the east into what is now the Old George Mall. The inn was built in the third quarter of the fourteenth century but incorporated buildings that were already there. It was modified in the fifteenth and seventeenth centuries and belonged to the corporation from 1413 until 1858, although, from around 1760, it was occupied as a dwelling rather than as an inn. In 1858 it became an inn again but was much altered and partly demolished.

The Old George Mall was built in 1966-71 and has been praised by some because of the low-key way it manages to hide a recent, and unspectacular, retail development behind a historic frontage.

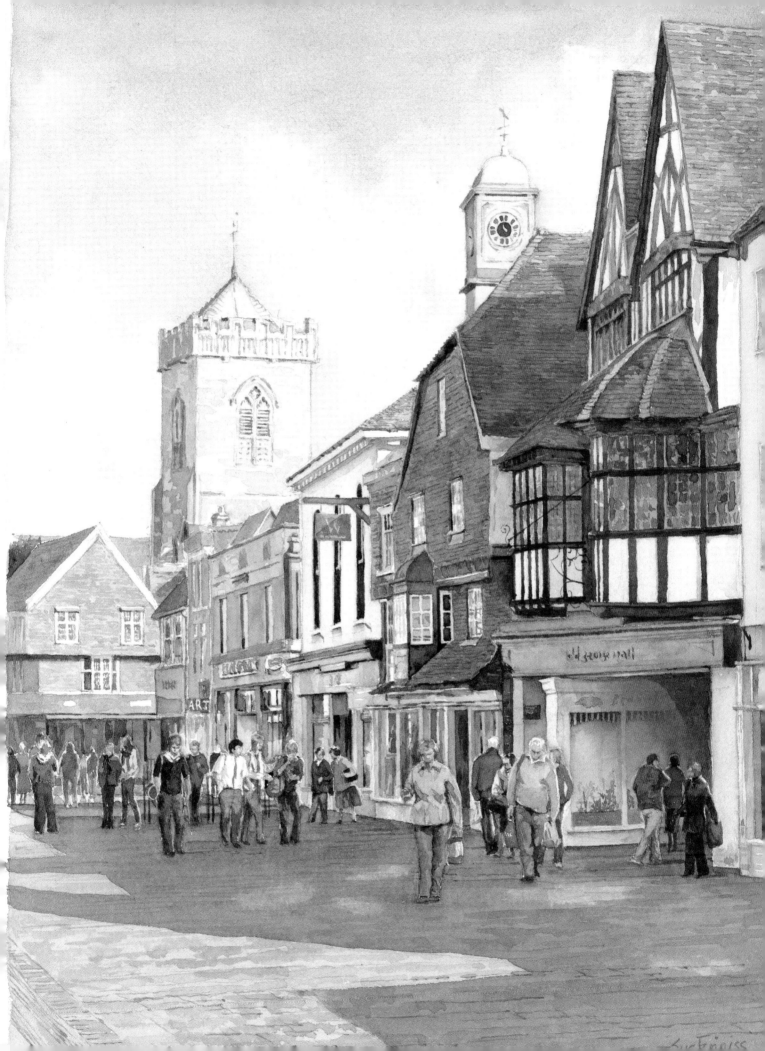

Poultry Cross

This view is from just beyond the south-west corner of the Market Square looking westwards towards St Thomas's church which is just visible above the houses.

This is the sole survivor of Salisbury's market crosses, which were intended to signify where certain produce was sold.

A structure of some kind existed here in 1307, the current hexagonal framework with four-centred arches having replaced it by 1448. It was repaired and improved in 1711, and then much restored in 1852-4 when the flying buttresses and pinnacle were added.

Originally this would have been one of four such crosses associated with the market. There was also a Cheese Cross at the south of Castle Street, close to what is today known as the Cheesemarket; a Wool Cross in New Canal, and Barnwell Cross (the cattle market) at the corner of Barnard and Culver Streets.

This was the focus for a giant anti-Papal demonstration in 1850. The *Salisbury Journal* reported how there was a 'mock procession of the Pope, his English Cardinal, and the twelve Bishops, all of whom were doomed to the flames in one of the biggest bonfires remembered in the West Country.'

After the start, in the late eighteenth-century, of a legislative process which gradually removed the sanctions that existed against Roman Catholic practices, a new confidence developed among them. In 1850 the Pope decided to re-establish a diocesan structure in England and Wales and he appointed Cardinal Wiseman (1802-65) to act as the head of the Catholic Church here. For many this was seen as 'Papal Aggression' and an attempt by a 'foreign power' to exert influence from the pulpit and through the senior clergy which could be counter to that of the elected government. The papers were full of it and apparently so were some of the good people of Salisbury who staged a protest. The procession received criticism in the *Salisbury Journal* and appears to have been supported by a minority.

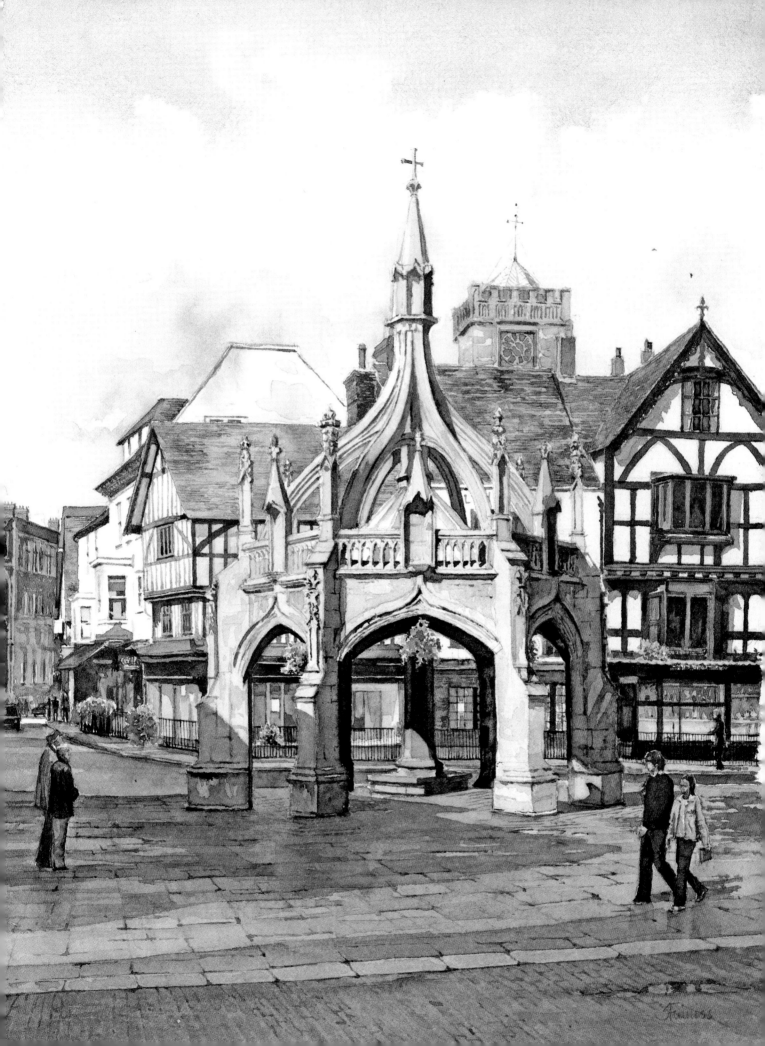

Church of St Thomas of Canterbury

This was, and still is, the principal parish church of the city. It served the merchants who created Salisbury's great medieval wealth. It is located at the far northern end of the High Street while the entrance to the cathedral Close is at the southern end.

No sooner had work started on building the cathedral than attention turned to the provision of a church for the people of the new city. As early as 1238 a chapel of some sorts seems to have been erected in this area and by 1246-8 there is specific mention of a 'church of St Thomas of Sarum' which it seems might have been cruciform in plan. A parish existed by 1269. The tower was added on the south side in 1400, though originally it may have been detached from the nave.

However, nothing remains of this thirteenth-century church. The chancel collapsed around 1448 and was then rebuilt to include what had been the crossing of the original church. At about the same time the north and south chapels were rebuilt and then the nave and aisles, which were widened to abut the tower and lengthened to the west.

What you see today is a strong statement of the fifteenth-century architectural style, with large Perpendicular windows flooding the interior with light - a striking contrast to the narrow Early English style of the thirteenth century which was used in the cathedral.

The most striking decorative feature is the Doom painting from the fifteenth century but it 'disappeared' in 1593 when it was painted with 'lyme' and not restored to view until the late nineteenth century. The dead are raised on the left while the damned descend into Hell on the right. Above Christ awaits the just along with his mother, St John and the saints. A chilling warning for any who broke the religious rules!

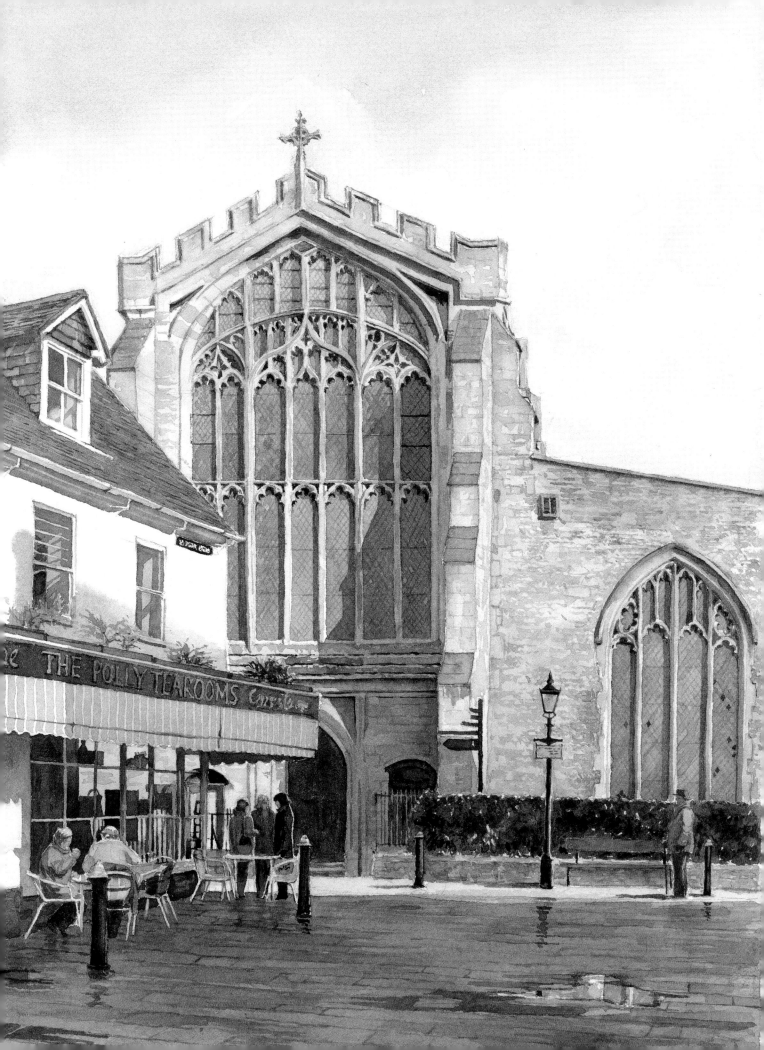

The Maltings

This area, to the west of the medieval city, now mostly comprises retail units and a large car park.

Here we can see the river Avon which runs through Salisbury, a former mill and the cathedral tower and spire - a true union of matters secular and ecclesiastical.

The rivers powered the mills which generated the economic wealth that made medieval Salisbury one of the leading cities in England and provided much of the finance that was needed to build such a splendid cathedral.

This area was also where malting was undertaken and it was later fed by a branch of the railway from Fisherton to the Market Square which opened in 1859. Malting is the process whereby barley is germinated by the addition of water. The process takes about five days and the malted grain is then ready for use in the creation of ale, the staple drink before water became safe.

Today much of this area is a large car park but the part to the south and east of the site has been developed for mixed retail and residential use.

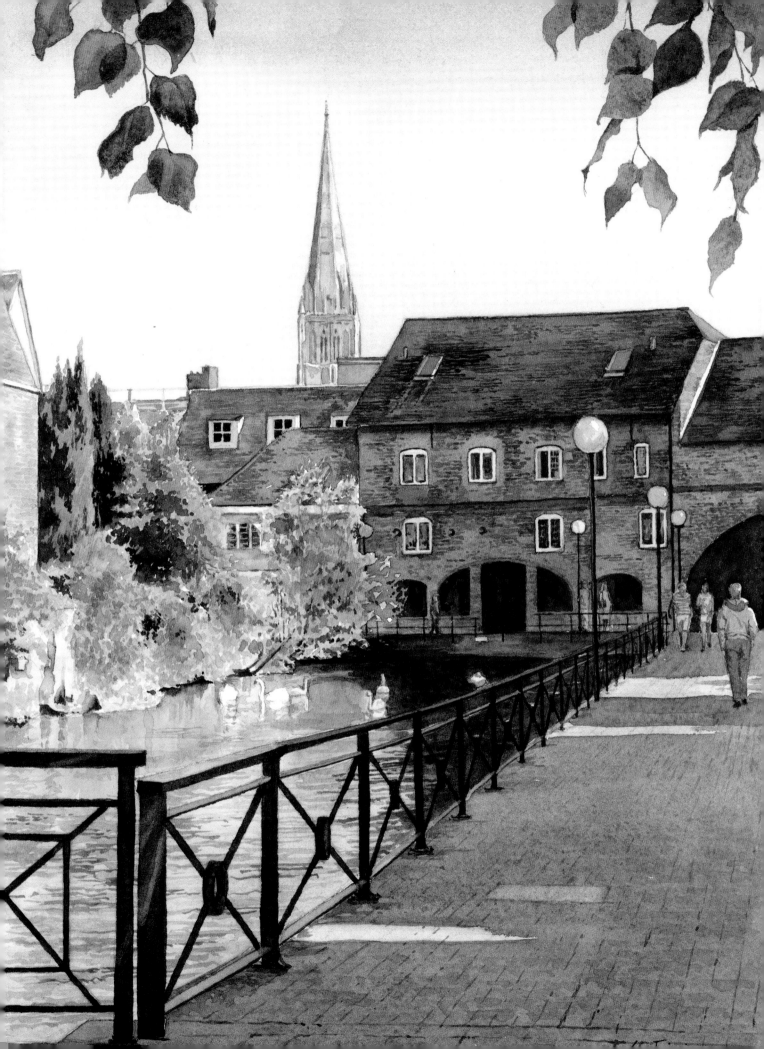

Town Mill

Located on Bridge Street, the Town Mill was one of the original city mills, though one with an interesting later use.

The Town Mill complex probably occupies the site of an earlier mill which was built by Bishop Poore in the thirteenth century. The present mill is a mix of eighteenth- and nineteenth-century buildings, mostly from 1757 with additions in 1889. The whole spans an arm of the river Avon.

The original building would have played its part in the economic development of Salisbury and its cloth trade. In 1562 it housed one of Salisbury's fulling mills. See Harnham Mill for more information on the fulling process.

In the nineteenth century more modern sources of power became available and Salisbury gained its first gas company in 1832. An electricity company did not follow until the end of the century when The Salisbury Electric Light & Supply Co Ltd started to generate hydro-electricity from the water cascading below the Town Mill. Electricity generation continued at the Town Mill until the end of World War II.

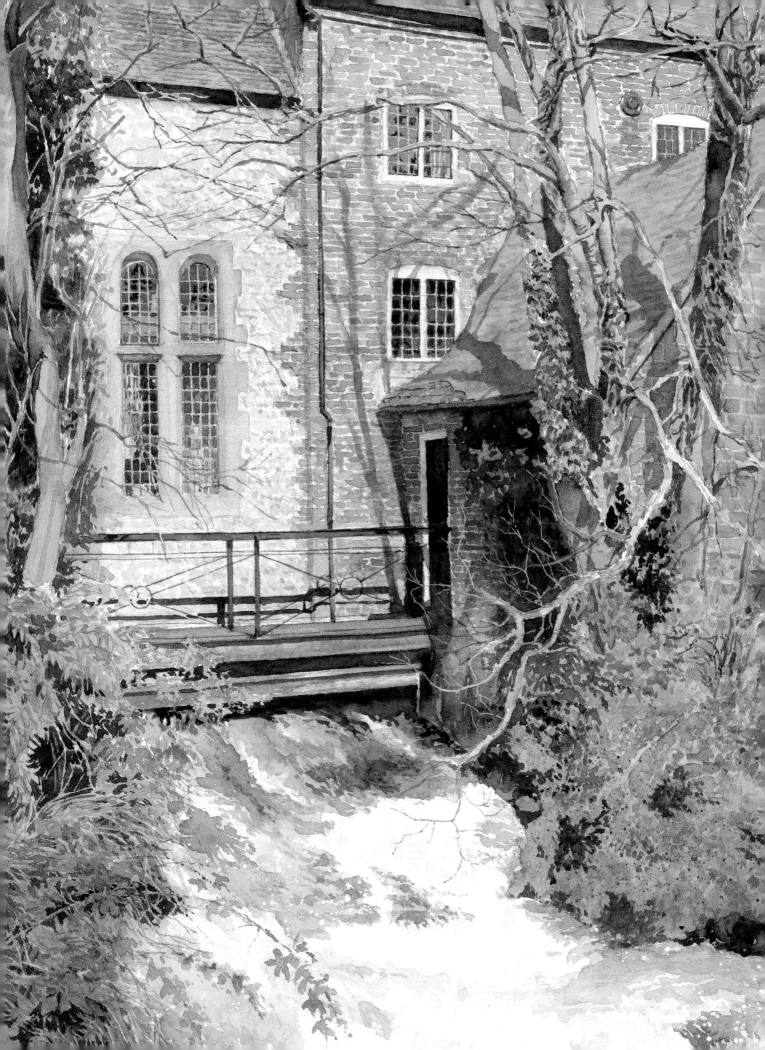

United Reformed Church

This is located on the northern side of Fisherton Street and is one of Salisbury's most picturesque landmarks.

This is one of the most spectacular church façades in Salisbury with a magnificent tower and spire. Opened in 1878 to the designs of Tarring & Wilkinson from London, the church evidences the rise of religious plurality and of Congregational non-conformity in particular in a city dominated by the Church of England.

The frontage, built in the Gothic style of around 1300, is deliberately assymetrical with the steeple placed to the east of the nave. It has a broached spire with prominent corner pinacles. A large five-light window over the main entrance lights the nave.

The Fisherton area was developed in the nineteenth century and Fisherton Street provided a busy conduit between the city and its growing suburb and the railway station, which was built there to Brunel's designs in 1856.

The railway first reached Salisbury on 27 January 1847 when the London & South Western Railway opened a goods service to a station at Milford, east of the city. A passenger service followed by March and a train left the terminus four times a day which travelled via Bishopstoke (now Eastleigh), to Nine Elms between Battersea and Vauxhall, so 'affording the inhabitants of Salisbury and the surrounding country the very desirable facility of a passage to the great metropolis in four hours'.

The Wilts, Somerset & Weymouth Railway built a line to Brunel's broad gauge which ran north-west towards Warminster from a site in Fisherton in June 1856. A more direct route to London, via Andover was added in May 1857. Work extending this line towards Yeovil and Exeter had started in 1856 and was opened to Yeovil in 1859. A link line to join the Milford terminus with that in Fisherton was opened that year and the station complex at Fisherton became the new railway focus for the city.

The effect of these changes was to create a new economic focus slightly to the west of the old city and Fisherton became one of the growth areas over the next hundred years.

The United Reformed Church recognises this change of emphasis, and perhaps also gives an indication of the more working-class nature of the population of this area and its preference for non-conformity over the Church of England.

The church was threatened with closure but has survived. It was reordered internally in 1978 to provide a worship space upstairs and a range of rooms below.

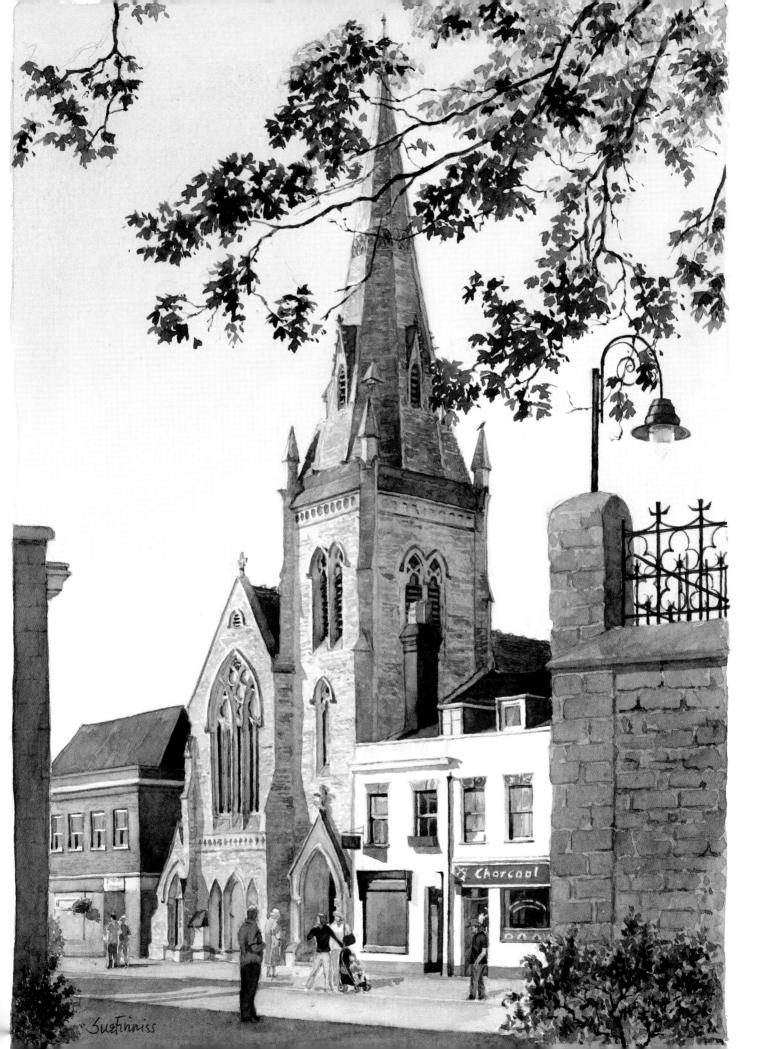

Clock Tower

Located on Fisherton Street, just west of the Fisherton Bridge over the river Avon.

The spectacular clock tower, so typical of those in other towns and cities, was presented to the city by Dr Roberts and erected in 1890. In an age before radio, television and digital watches a clock brought a sense of time to an urban community.

Below the clock tower are the remains of the gaol which was built in the sixteenth century. This was replaced by the County Gaol which was built outside the city, on the Devizes Road, in 1818-22. The old gaol survived until 1843 when most of it was demolished.

The fragment that remains probably dates from 1783 when a number of new cells were added. Its use is well illustrated by the stone panel that shows the shackles which may have been used on the inhabitants.

Prior to the nineteenth century gaols were chiefly used to hold prisoners pending trial, after which many were usually released, deported, or for 'serious offences' executed. The concept of gaols to house long-term prisoners is a more recent development and explains the great prison-building programme that was started in Victorian times.

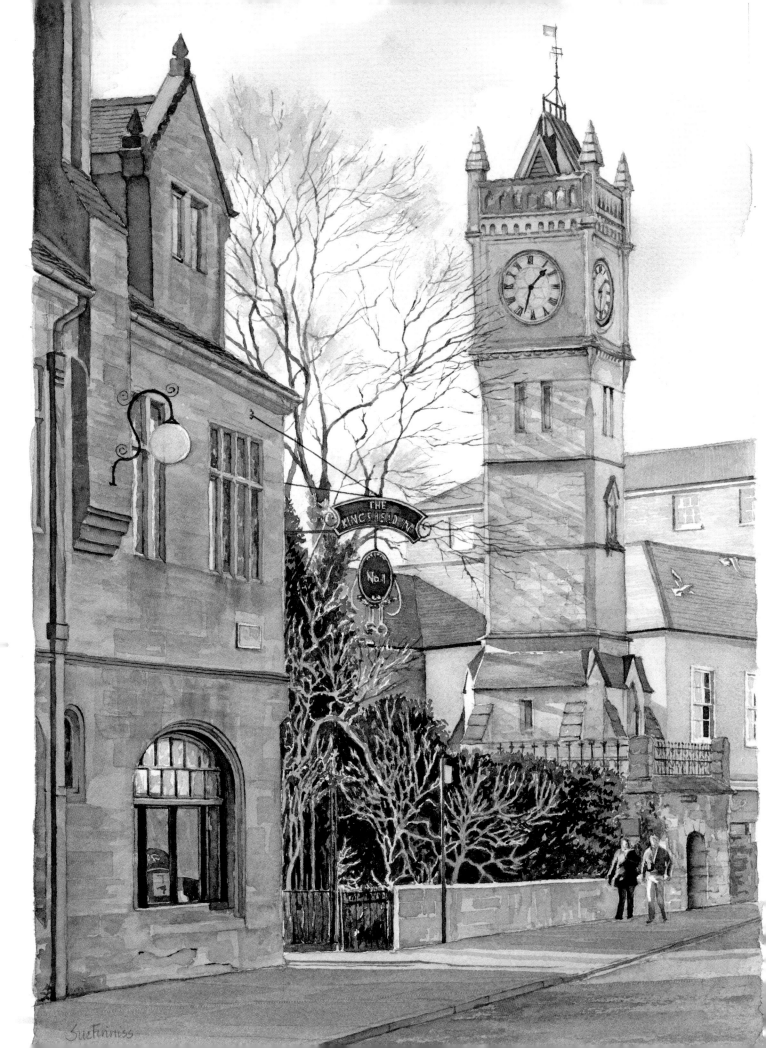

Church House

Located on the south side of Crane Street just before one of the medieval bridges which linked the city with its surrounding countryside. The bridge has been rebuilt at regular intervals, the most recent being in 1898 and 1970.

Church House has three ranges - north, west and south - gathered around a central courtyard which is accessed through the archway.

The stone north range, which abuts Crane Street, appears to date from the latter part of the fifteenth century and was originally a domestic dwelling, though the windows on the left and above are much later.

The origins of the west range are slightly later. It was most probably built in the early sixteenth century and contained a great hall which was chambered over a century later so as to create an upstairs. A stair tower was added at this time. The spectacular gabled and part tile-hung extension on the right is much later, and mostly from the late nineteenth century, though replacing earlier work.

In 1634 these two ranges were bought by the city and converted into a workhouse. The south range was added in 1728 to provide more pauper accommodation. The workhouse moved to another location on the Blandford Road in 1881.

The whole complex, and especially the west range was restored and improved in 1881 when the workhouse was relocated. The spectacular gabled and part tile-hung extension on the right was part of these works. Two great chimneypieces were brought in at this time, one from Longford Castle and another from elsewhere in the city.

Today this complex of buildings is home to the Salisbury Diocese and provides administrative space for the staff involved.

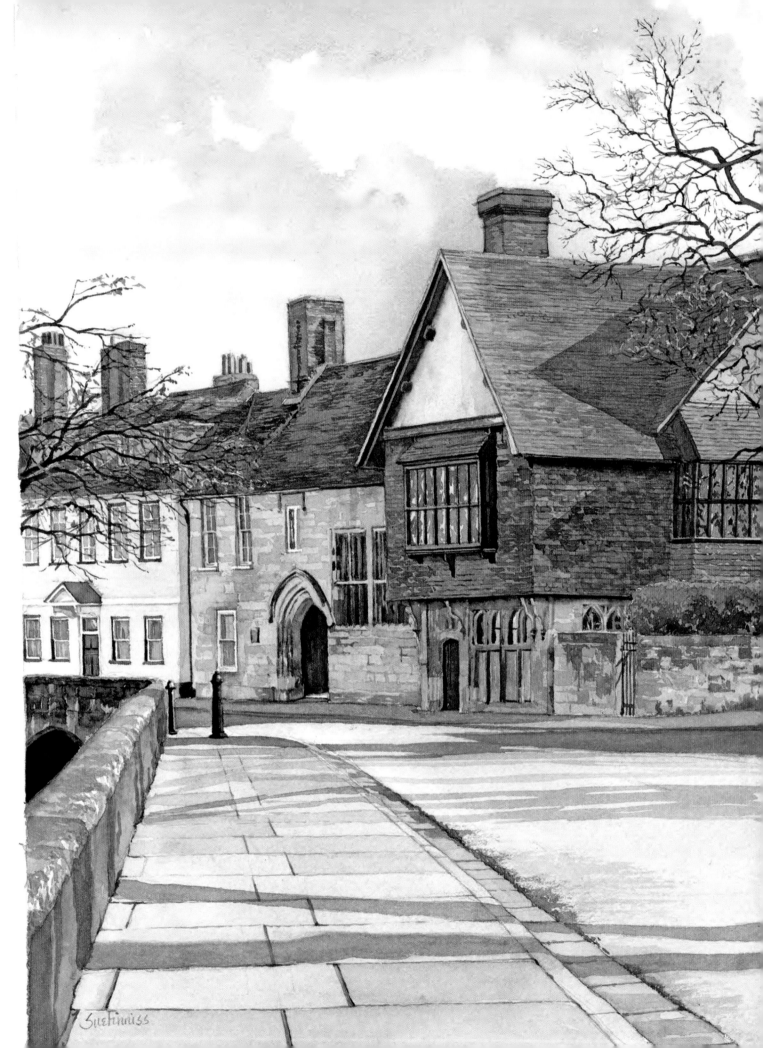
Sue Firmiss

Water Lane

This rather secluded passageway runs south from Fisherton Street to join Crane Bridge Street opposite Queen Elizabeth Gardens.

You are never far from water in Salisbury. The city and its surrounding area is the meeting point of five rivers that combine to create the mighty Avon which then flows south to join the sea at Christchurch.

Water was also the foundation of Salisbury's medieval wealth powering the fulling mills that were at the centre of the city's prosperity and dominance in the cloth trade in the fifteenth century. Later, in 1724-6 Daniel Defoe (*c*.1660–1731) recounted how 'The city of Salisbury has two remarkable manufactures carried on in it, and which employ the poor of the great part of the country round; namely, fine flannels, and long cloths for the Turkey trade, call'd Salisbury Whites.'

The River Avon also fed the water channels which flowed through many of the streets and created, what has often been called, a 'Venetian' atmosphere. However, Defoe was not impressed, as by the eighteenth century the water 'keeps the streets always dirty, full of wet and filth, and weeds, even in the middle of summer'. Inevitably the water channels became repositories for rubbish and sewage and were covered over after the catastrophic cholera epidemic of 1849.

Today Water Lane provides a quick cut-through and is lined with late-nineteenth and early-twentieth century artisan houses.

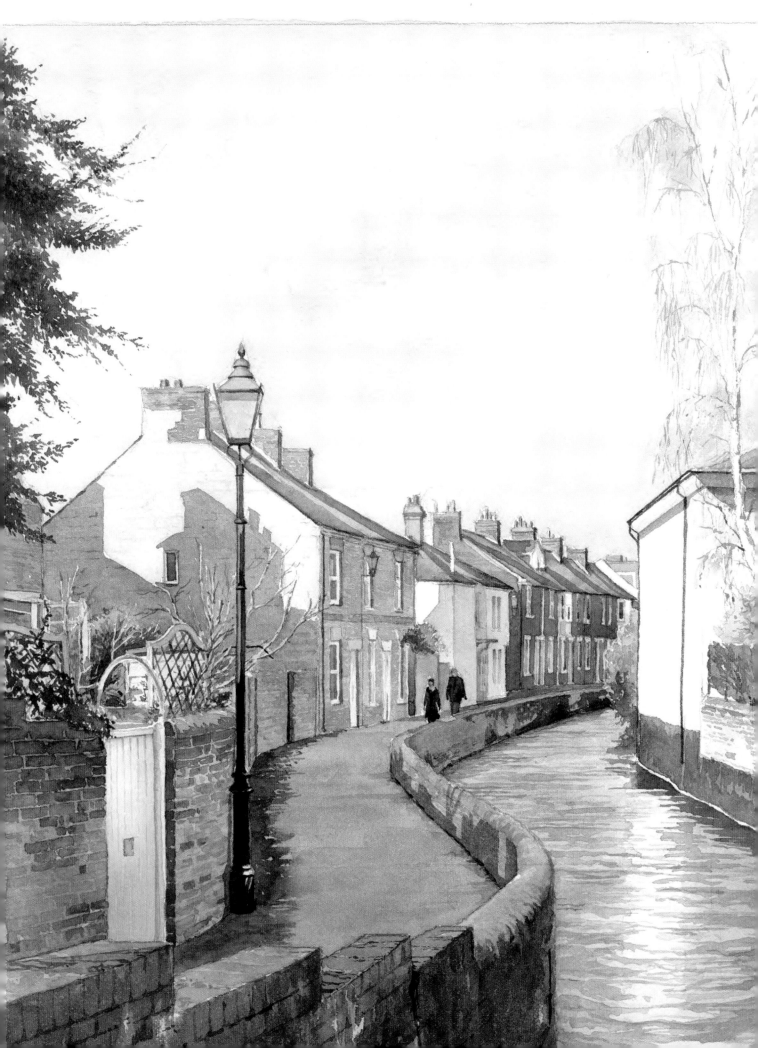

Cathedral from Queen Elizabeth Gardens

The cathedral dominates Salisbury and provides some spectacular views. This one is taken from the Queen Elizabeth Gardens to the north-west of the cathedral.

Work on the cathedral started in 1220 and by 1258 sufficient progress had been made to allow the building to be consecrated.

However, at this stage there was no tower or spire, these being added in the fourteenth century. The effect was to transform the building and to make Salisbury's cathedral one of the most spectacular in England.

The Queen Elizabeth Gardens are off Crane Bridge Street to the south-west of the city centre and they provide an open green space adjacent the heart of the city. They were created in 1953 to commemorate the Coronation of Queen Elizabeth II, having previously been Gullick's Nurseries.

From here you can see the gardens of a number of the grand houses which occupy the western side of the cathedral Close and there is one of the best views of the cathedral tower and spire.

The Queen Elizabeth Gardens also provide a link between the city and the Long Bridge that leads onto the town path which crosses the water meadows to Harnham Mill.

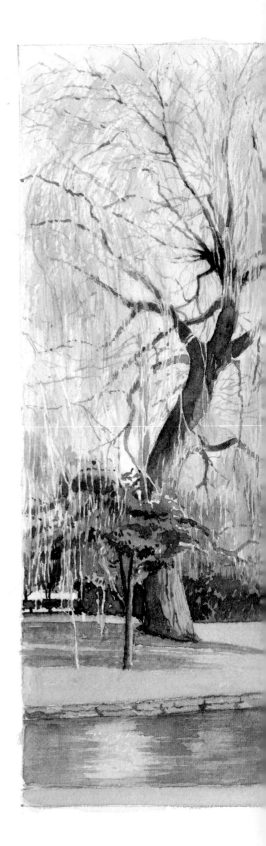

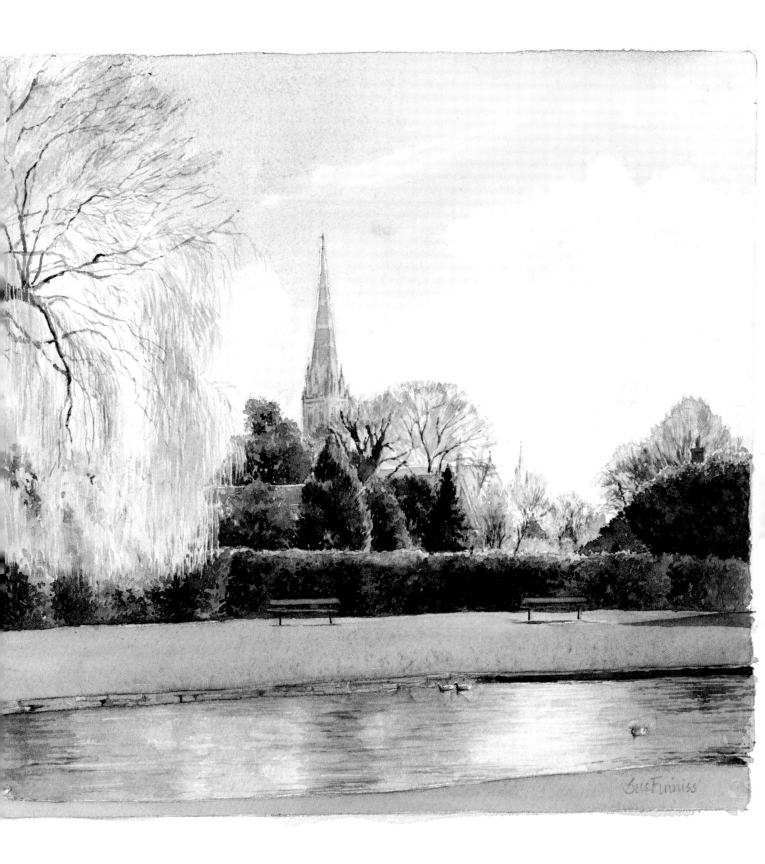

Cathedral from the water meadows

This view is from the Long Bridge that connects the Elizabeth Gardens with the pathway to Harnham.

It is from the west that one gets perhaps the best view of the cathedral and it is a view that has been painted by many, most notably John Constable.

John Constable (1776-1837) was a friend of Archdeacon John Fisher who lived at Leadenhall in the Close and was a nephew of Bishop Fisher (bishop 1807–25). Constable painted the cathedral several times. Around 1820 he painted *Salisbury Cathedral from the River*, and somewhat later, in the 1830s, he painted *Salisbury Cathedral from the Meadows* which was exhibited at the Royal Academy in 1831.

The water meadows, which occupy much of the land between the cathedral Close and Harnham, were economically important during the late seventeenth and eighteenth centuries. The land was ridged and connected to the river with water channels that flowed along the top of the ridges and then deposited the water down the ridge sides into other channels between the ridges that returned it to the river. Using this technique the meadows were flooded in the early spring and a particularly early crop of grass was produced which left time for a later crop as well. This provided early rich grazing for the vast flocks of sheep which then manured the corn fields. This process increased agricultural output and was probably one of the improvements that enabled agriculture to feed the rapid growth in population, and the move from rural to urban living that occurred in the nineteenth century.

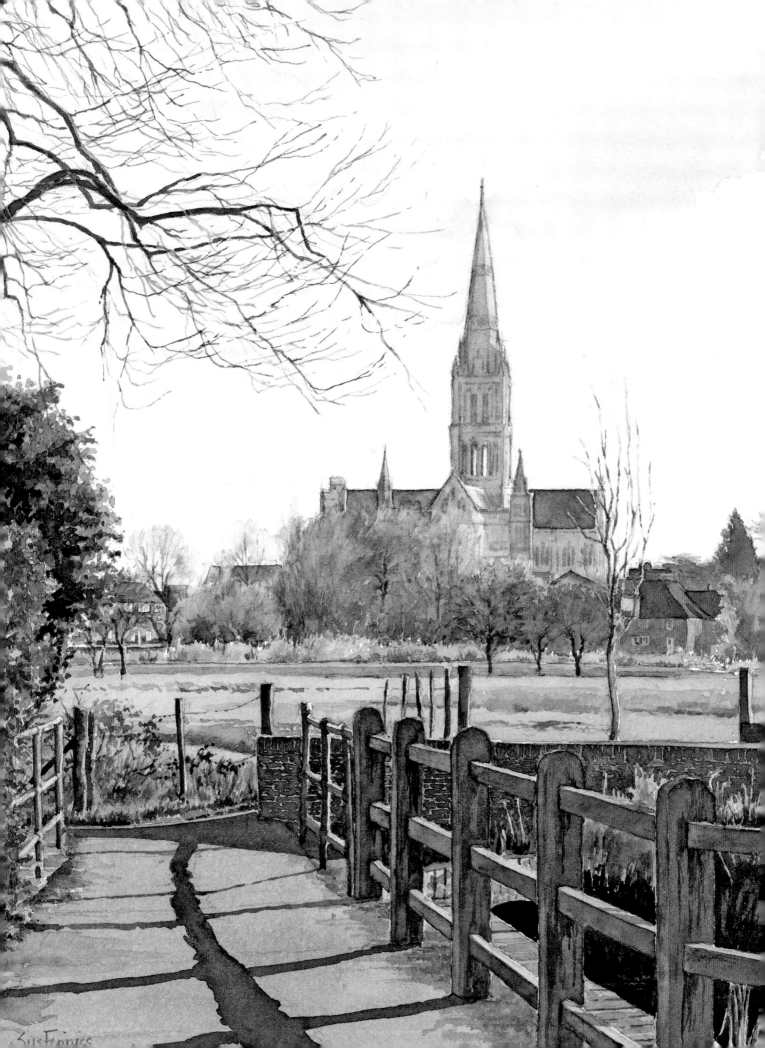

Harnham Mill

Harnham lies to the south and west of Salisbury and is connected to the city by a footpath which leads to the Harnham Mill and a bridge which gives road access to the area around the Rose & Crown.

Salisbury was an important centre for the cloth trade. With five rivers converging in or near the city it was well placed to exploit the technology of fulling mills in buildings like Harnham Mill. Fulling was one part of the cloth-making process and involved the woollen cloth being beaten with wooden hammers which were powered by a waterwheel. This process cleansed the wool and eliminated oils, dirt and other impurities. It also made the cloth thicker.

It seems likely that fulling may have taken place here before 1300, though the current building originated around 1500. An adjoining three-storey cloth factory was added in red brick in 1810 and this became the miller's house. It is to the left of the mill building. Today Harnham Mill and the cloth factory are a restaurant and hotel pictured here.

The mill building is of two storeys. The walls of the south façade seen here are chequered with flints and ashlar blocks below with brick above which replaced earlier timberwork. The east wall is mostly original as are two windows and doors in the south façade. The single-storey north extension at the rear was rebuilt in the eighteenth century.

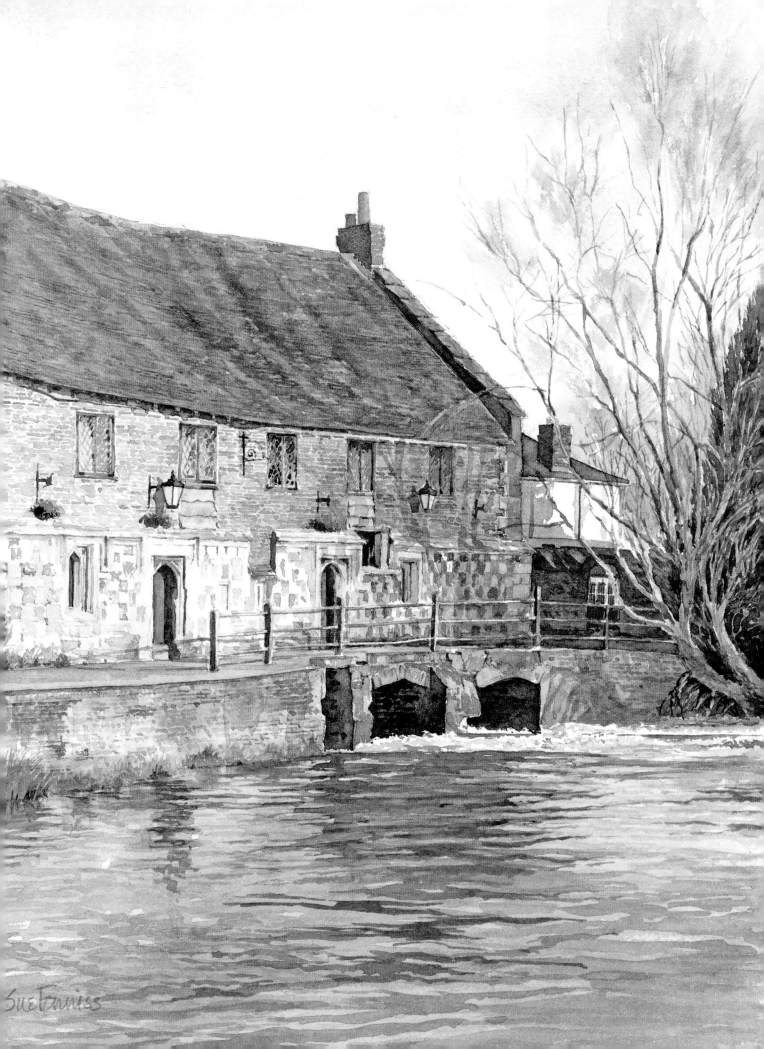

Sue Farriss

Rose & Crown, Harnham

Located just before you re-enter the city on the south side of the cathedral Close on the Harnham side of Ayleswade Bridge.

Harnham lies to the south of the city and in medieval times was accessed via the Harnham or Ayleswade Bridge which was built by Bishop Bingham (bishop 1229-46) in 1244. The traffic this route attracted transformed the fortunes of the area. To care for travellers Bingham endowed St John's Chapel nearby and also St Nicholas Hospital.

For many, the Rose & Crown provides a picturesque image of a medieval building. It is located on the ancient travellers' route through Salisbury and would have provided stop-over food and lodgings for those who preferred staying somewhere outside the city.

The oldest parts of the building are the north and west ranges - the north one visible in the painting and the west range lying behind it. They are both from the fourteenth century and have timber-framed walls infilled in places with plaster or with brickwork. The north range has an original crown-post roof. Both ranges were extensively modified in 1963. The south range - which starts on the left side of the painting - was built in the sixteenth century.

In the north range there is much original timber in the jettied upper storey, and there is also an original square-headed window with four narrow unglazed lights towards the right. The projecting bay window is more modern. The jettying in the south range has been underbuilt with modern brick.

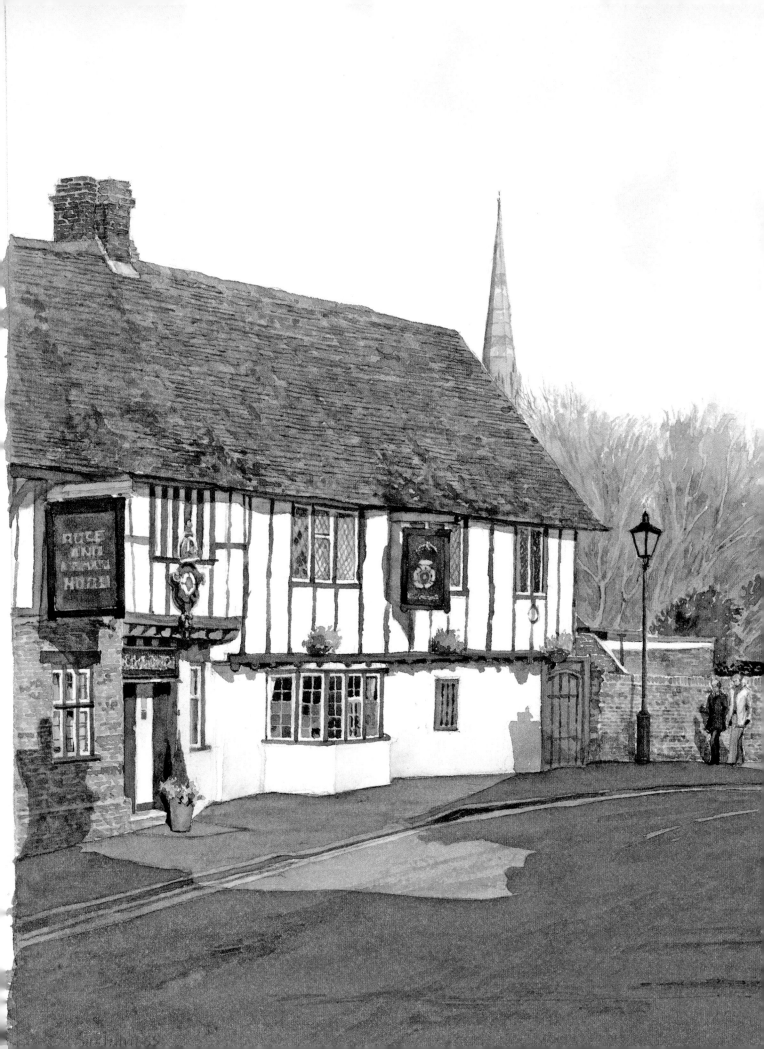

St Nicholas Hospital

This is a rather unusual view of the hospital from across the river looking north.

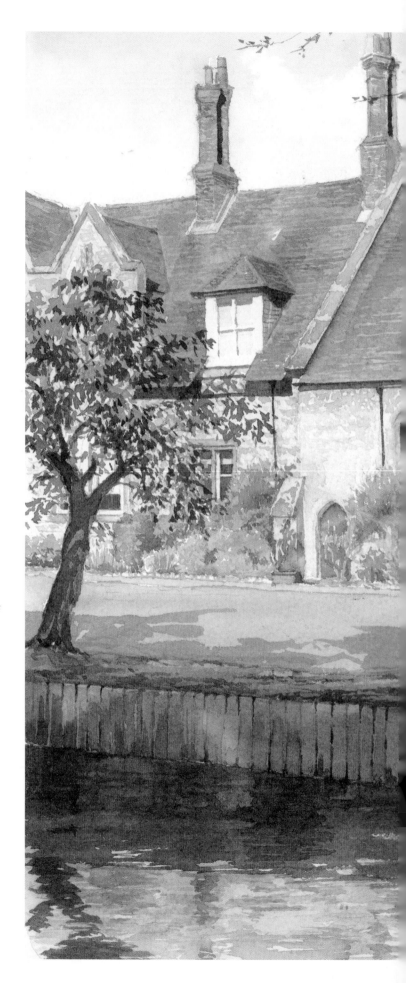

The hospital originated in the thirteenth century and was intended to provide for the sick and elderly. The location was adjacent to the cathedral Close and the main road which ran north/south and crossed over the river here. Anthony Trollope (1815/6-82) lampoons such establishments in his *Chronicles of Barsetshire*.

Bishop Bingham (bishop 1229-46) probably commissioned the building in 1231 when royal grants made timber available for its construction, though it seems likely that a smaller building had already been built around 1227. The whole was much restored and altered in 1850 and again in 1884.

The original plan involved two parallel ranges and this picture shows the eastern end of the south range. The north range provided accommodation for the warden and chaplains, while the south range seems to have been divided into two parallel aisles, each terminated at the eastern end by a chapel.

Today the hospital has been further extended and continues to offer care and comfort to the elderly within a Christian environment.

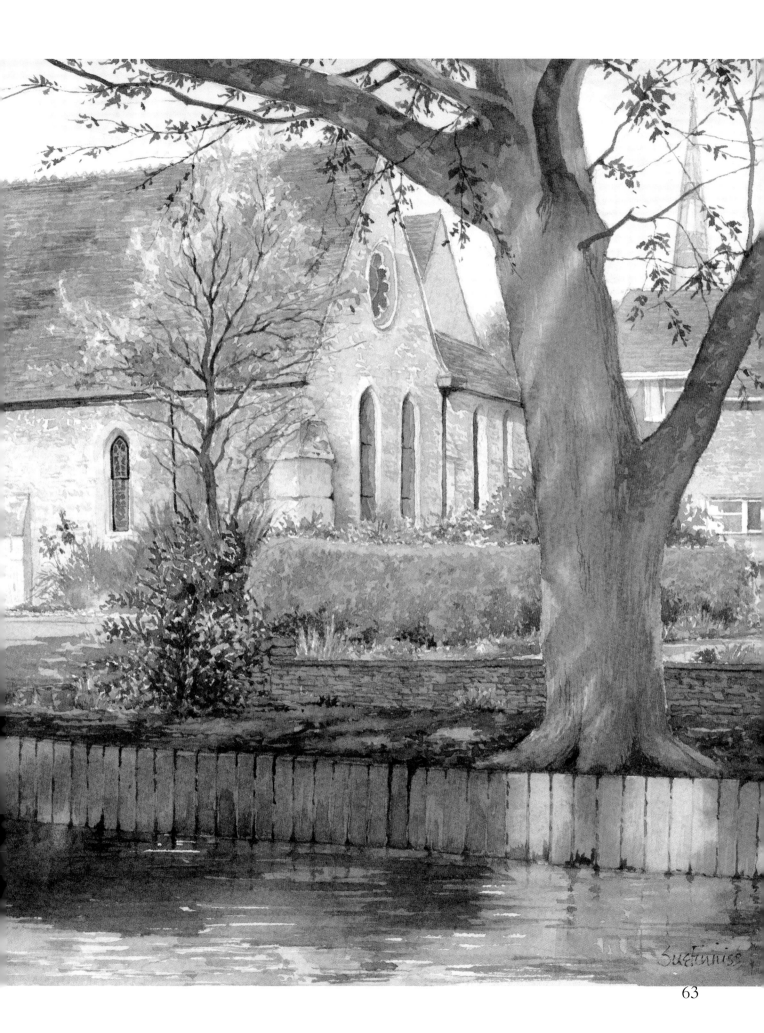

Sue Finniss

Myrfield House

The painting looks north. Ahead and on the left, and out of view, is the Harnham Gate which provides access to the Close. Behind us lies Harnham Bridge.

The façade of Myrfield House, with its three-bay brick-built symmetry and order, is Georgian in style and was built in 1813. Its spirit is very much of the time in that it projects all its glories at the front, masking the fact that there are no windows on any other side because they would have overlooked the gardens of the old Bishop's Palace (now the Cathedral School).

Inside there are rooms on the right and left with a central vestibule that contains the staircase and is top-lit. On either side of the house there are single-storey ranges that originate from the eighteenth century and were cottages and shops.

Just visible on the left is De Vaux House which is mostly of around 1700 but incorporates parts of a much older medieval house that dates from 1260 and was De Vaux College. This was Salisbury's centre of learning in the Middle Ages but had long declined before it was dissolved in 1542.

In the nineteenth century De Vaux House found a new use as a Magdalen Penitentiary, or house for fallen women. This was established in 1831 as the Wilts Female Penitentiary Association and run by a group of ladies from the Close. The home would provide accommodation and correction for up to twelve women. It would be 'an asylum to that unhappy class of our fellow creatures whose melancholy situation necessarily renders them outcasts of society' said the *Salisbury & Winchester Journal* on 26 December 1831. Those women who did not abscond or get expelled, stayed for two years before entering domestic service.

The home operated at De Vaux House until 1848 when it transferred to bigger premises in what is now the northern extension of Salisbury College. During the eighteen years of its operation the home admitted 141 women.

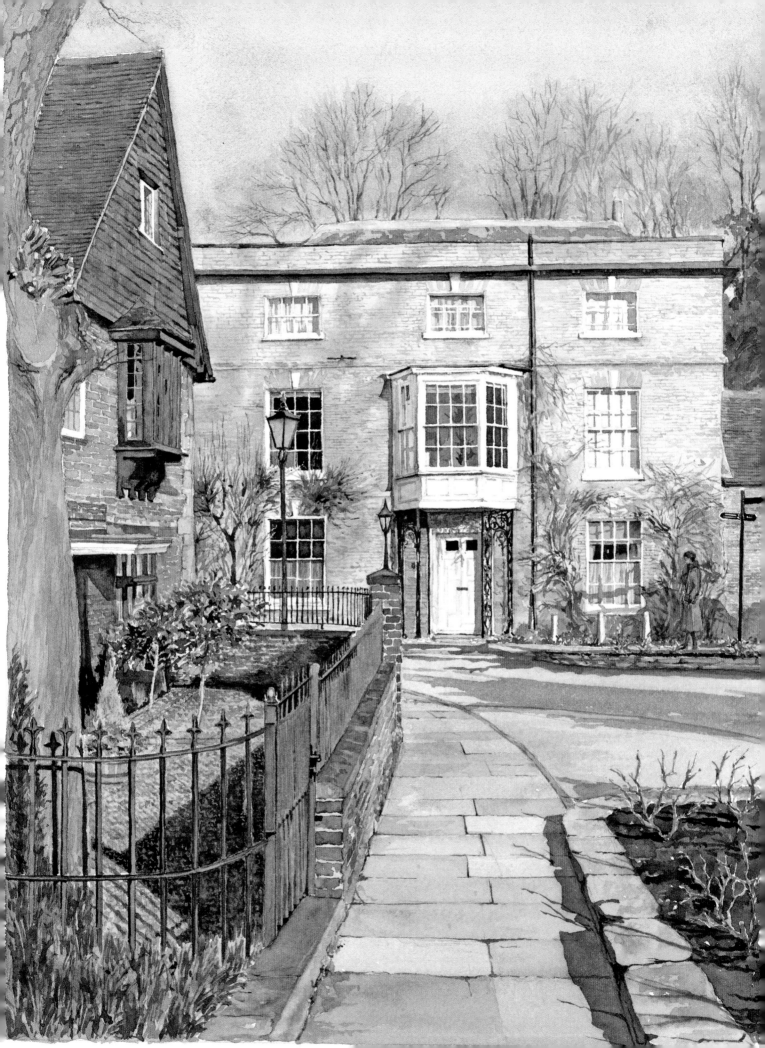

St Osmund's Church

This is the oldest of Salisbury's three Roman Catholic churches and is located on the east side of Exeter Street.

Prior to the mid-nineteenth century the Roman Catholics of Salisbury worshipped in temporary accommodation. Initially this was in private houses and then in rented premises. However by the mid-1840s their numbers had grown sufficiently to enable them to contemplate building a new church.

One of the principal architects of the day was A. W. N. Pugin (1812-52) who had lived nearby at Alderbury, about two miles south-east of the city, between 1835-7. He had converted to Roman Catholicism in Salisbury on 6 June 1835 and remained in regular contact with leading members of the local Catholic community, including John Lambert who was to become mayor of the city in 1854, and John Peniston who provided a piece of land on Exeter Street for the present church, for which, in 1846, Pugin was asked to produce drawings. The foundation stone was laid on 8 April 1847 and the building was consecrated on 6 September 1848.

Pugin had always regretted the Reformation and also what he considered to be the architectural despoliation that had been carried out on the cathedral in more recent years. His church was dedicated to St Osmund (whose tomb is in the cathedral), and it was intended to be an 'inexpensive miniature' which showed how a church should be.

The building was extended with a north aisle in 1894 and has recently been renovated. The adjoining parish rooms were built after the church but before the extension. They have also recently been renovated and extended.

The red-brick building in the foreground is the presbytery, or priests' house, and is much older. The façade originates from the late eighteenth century, though this conceals two earlier sixteenth-century houses: all very typical of the sort of refacing and reordering that occurred during the eighteenth century all over Salisbury.

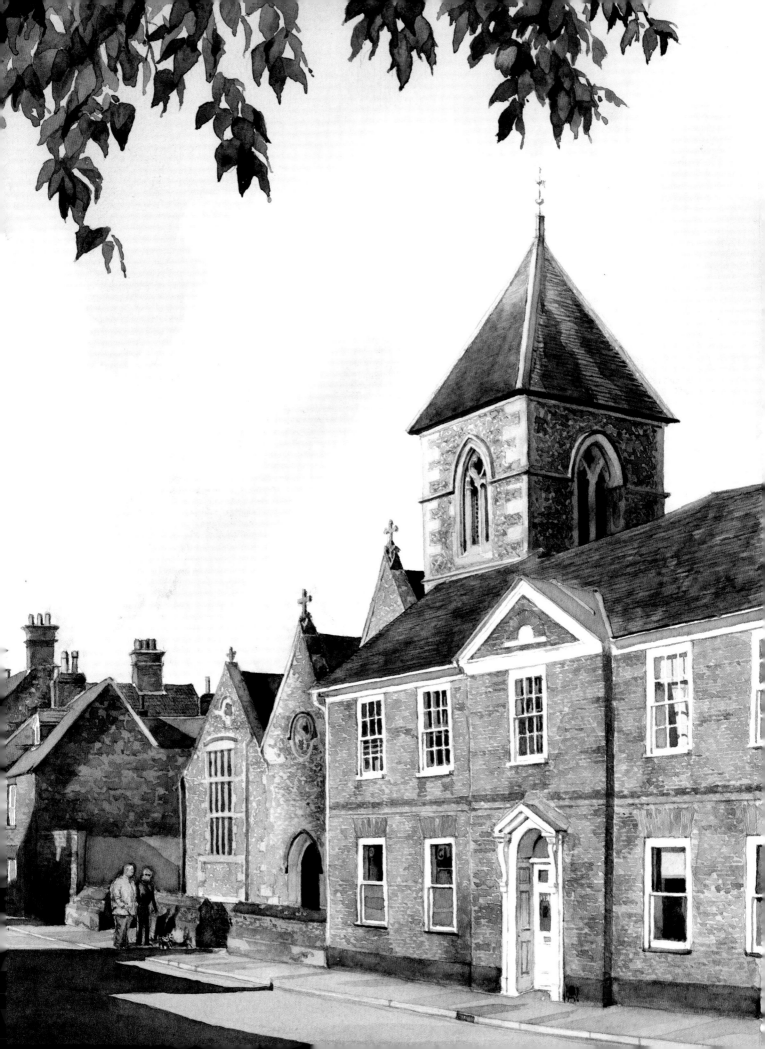

White Hart

Located at the junction of St John Street, Catherine Street, Ivy Street and New Street.

The building with the projecting portico and *porte-cochère* below is the White Hart Hotel. The buildings on the right are later additions to the hotel while the somewhat lower building beyond the traffic lights is the Cloisters; previously known as the Bell & Crown Inn.

The White Hart was built around 1820, though an inn had existed on the site as early as 1635. Its sheer grandness speaks volumes about the wealth of some of Salisbury's visitors at that time. A particularly elegant assembly room was added on the first floor around 1840, though this has since been subdivided as bedrooms. The hotel was extended in 1970-1 with the buildings shown on the right. From the balcony, the successful candidate in parliamentary elections traditionally sings an old Wiltshire song.

Despite the *c.*1750 sign on the outside, the Cloisters inn dates from the mid-fourteenth century. However, it has not always been an inn and the ground floor comprised four shops in 1415. Sometime later this building was given to the Dean and Chapter in exchange for the endowment of a chantry chapel in the cathedral. The façade is part jettied and today the upper façade is covered with mathematical tiles; a Georgian method of refacing a medieval building at low cost (see Butcher Row).

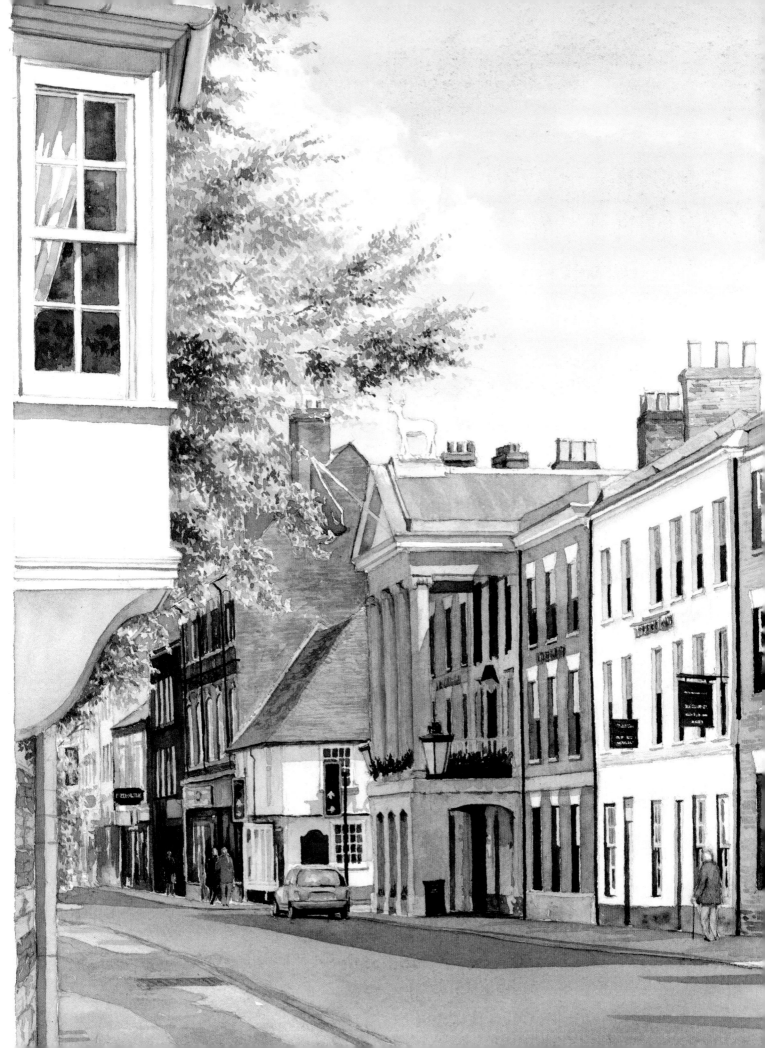

Joiners' Hall

This picturesque twin-gabled building is on the south side of St Ann Street.

The Jacobean style of the north façade suggests that this building dates from the early part of the seventeenth century, and a closer look shows that much of the original has survived. The fine façade with its grotesque timber corbels is probably the work of Humphrey Beckham, chamberlain of the Joiners' Guild.

There are two entrances which evidence the nineteenth-century conversion into two separate dwellings. This was reversed in the second half of the twentieth century when the building was restored to single occupancy.

The whole is of two storeys with attics, and while the lower walls are of rendered brickwork and rubble, there is a timber frame above. The two large first-floor windows which project on brackets are perhaps the most striking feature.

The house has been painted by various artists. John Buckler drew it in 1805 and then William Twopeny in 1833.

The hall now belongs to the National Trust.

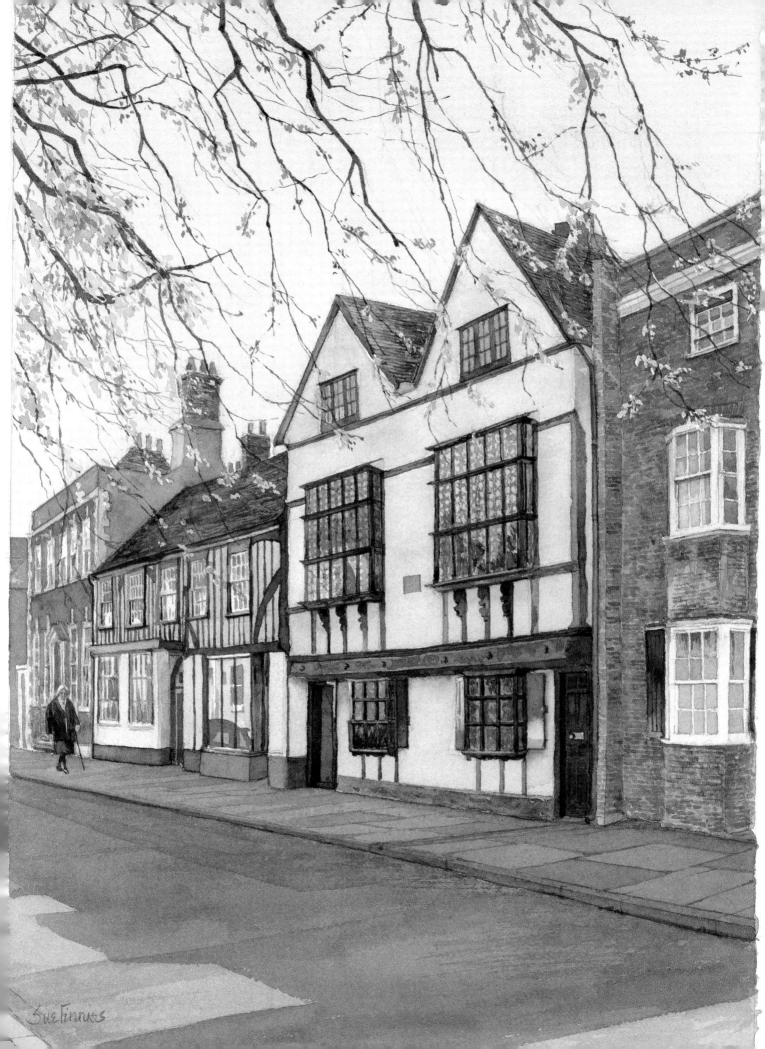

Sue Finniss

Cathedral from St Ann Street

This view looks west towards the cathedral and St Ann's Gate.

St Ann Street was one of the earliest thoroughfares that was created, and was formed to link the cathedral with the pre-existing ancient church and settlement of St Martin's. It was known as St Martin's Street until the sixteenth century.

Salisbury's cathedral was originally conceived without a tower and spire and would have terminated immediately above the roof.

However, the desire to create a spectacular building soon changed matters and plans were made to add a two-storey tower and top it with a stone spire. Work started in the early part of the fourteenth century and increased the overall height of the building to 404ft (123m).

Inevitably adding such a major structure to a building that was never designed to carry the weight involved, led to structural problems and rather quickly strainer arches and iron bracing were added within the tower to add some stability.

Then in the 1860s G.G. Scott (1811-78) undertook a thorough restoration of the cathedral and added four great scissor-braces within the tower. These have ensured that there is no longer any need to worry about the building's structural stability. The braces stretch across the diagonals of the tower and the V-sections at each end join to ironwork that is wrapped around the outside of the tower. This pulls the four corners in towards one another.

St Ann Street provides a good example of the rich structural variety which exists in Salisbury with medieval and eighteenth-century buildings interspersed with Victorian ones.

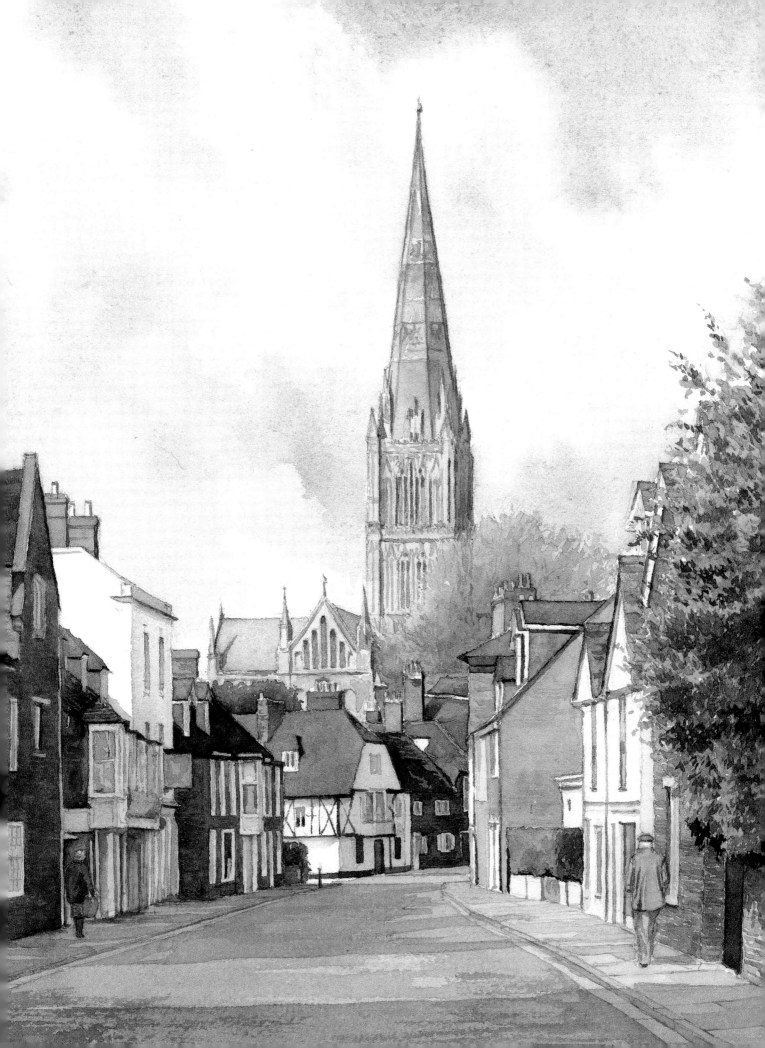

St Martin's Church

The church is located beyond the end of St Ann Street on the south-east outskirts of the city.

The settlement around St Martin's predates the city and there was a church on this site before work on the cathedral started and New Sarum was developed.

Just two small parts of a Norman church survive and both have been reset in the tower, and an excavation in 1956 also revealed the foundations of an early transept.

The present chancel dates from around 1230 and replaced an earlier structure. The tower is from the late thirteenth century though it may be a rebuilding of an earlier one. The remainder of the church (apart from the porch which is of the sixteenth century) is from the fifteenth century and the dominant style is Perpendicular.

The church was much restored during the nineteenth century. This work started in 1838 when changes were made to the chancel arch and chancel ceiling. In 1849 the chancel east window was replaced and a more comprehensive restoration followed in 1886, and with it the spectacular rood screen.

St Martin's still adopts High Church practices and a new stone altar and pyx have been installed during the last few years.

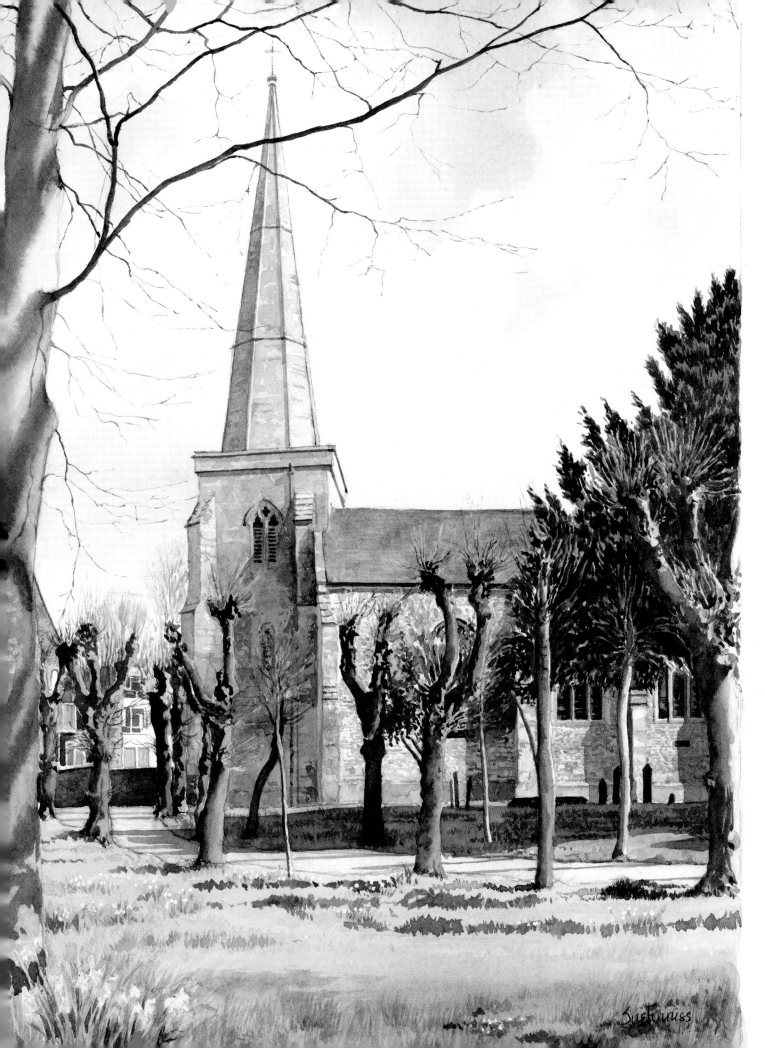

SueFinniss

Trinity Hospital

As its name suggests, this is located on Trinity Street which is a turning off Brown Street on the south-east side of the city.

A hospital was founded on this site in 1379 to provide accommodation for twelve elderly residents. The whole was rebuilt in 1702 and that structure mostly remains intact.

There are four ranges which are gathered around a central courtyard which is orientated north/south. The northern range holds the chapel and hall, while the east and west provide the accommodation. The entrance is from the south range which has a committee room above the archway.

The chapel was refurbished in 1908 and the whole complex modernised in 1950 when the accommodation was reduced from twelve units to ten.

The whole is an absolute delight, especially the chapel which has been little reordered. The complex still meets the same needs for which it was built almost seven hundred years ago.

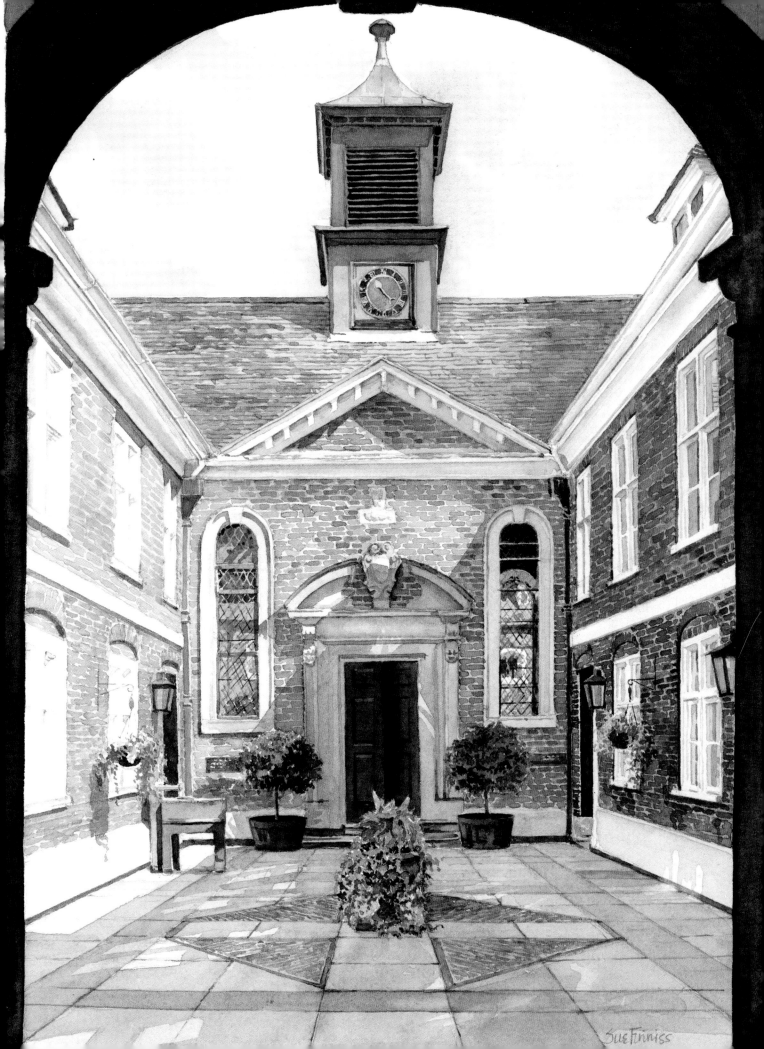

Sue Finniss

Brown Street Baptist Church

The church is set back slightly on the eastern side of Brown Street and opposite the car parks which give access to the city centre and Catherine Street.

Erected in the second half of the nineteenth century, this building proclaimed a new age. The days of a Church of England monopoly on religion had ended, and the Baptist form of non-conformity had amassed a substantial level of support in Salisbury and was able to afford and fill a large city-centre church.

The architecture also proclaimed a new era. The traditional building material - stone - had been replaced with the more fashionable and durable brick which was better at withstanding the effects of soot from domestic and workshop fires. The style is almost Italian and evidences an active interest in the architectural styles used overseas.

The history of Salisbury's Baptists begins at Porton where a group started to meet around 1655 and part of this group later transferred to Salisbury. By 1719 the Salisbury Baptists had a chapel on the present site in Brown Street which was rebuilt in the 1880s.

In 1851 the census not only counted the population but also the numbers who attended church on 'Census Sunday'. The returns still exist and show that the Baptist church had 218 adult worshippers in the morning along with 134 children; 142 adults and 225 children in the afternoon and 336 adults and 55 children in the evening - a total of over 900 worshippers.

In more recent times the church interior has been reordered and a mezzanine floor inserted to create an upstairs. Worship takes place on the first floor with meeting and assembly rooms below.

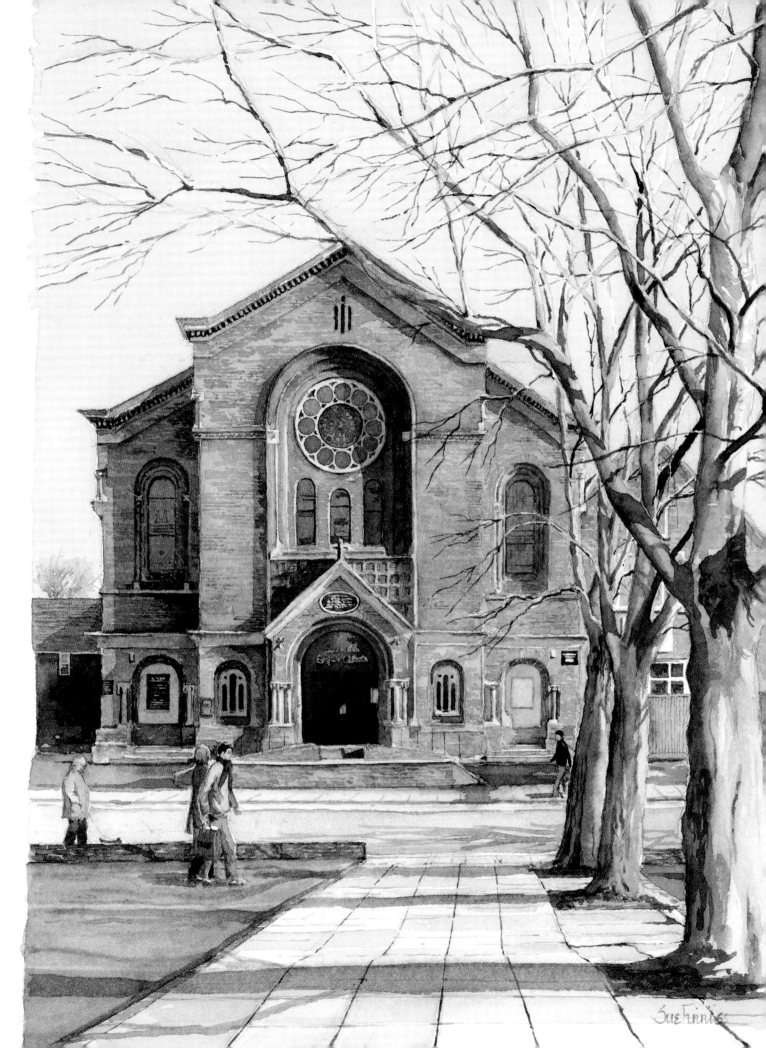

Red Lion

Located on the south side of Milford Street, the Red Lion is now a hotel.

Visitors to Salisbury required accommodation, and the Red Lion was one of several establishments which met that need.

The façade which fronts onto Milford Street was built in 1820-3 and provides access through an archway to an inner courtyard, and a timber-framed south range that dates from the first half of the fourteenth century.

The original inn - called the White Bear - was significantly bigger than the current building and probably stretched from the north-east corner of the chequer. It was renamed the Red Lion in 1756.

In the eighteenth century Salisbury became a hub on the coaching network. There was a limit to how far horses could pull a carriage before they needed to be changed and the passengers rested. Salisbury fell at a convenient spot along the route of those travelling east/west between London and the South West and was a major coaching centre. Here the coaches would have arrived, the horses would have been taken to the stables while the passengers were fed and accommodated in inns like the Red Lion.

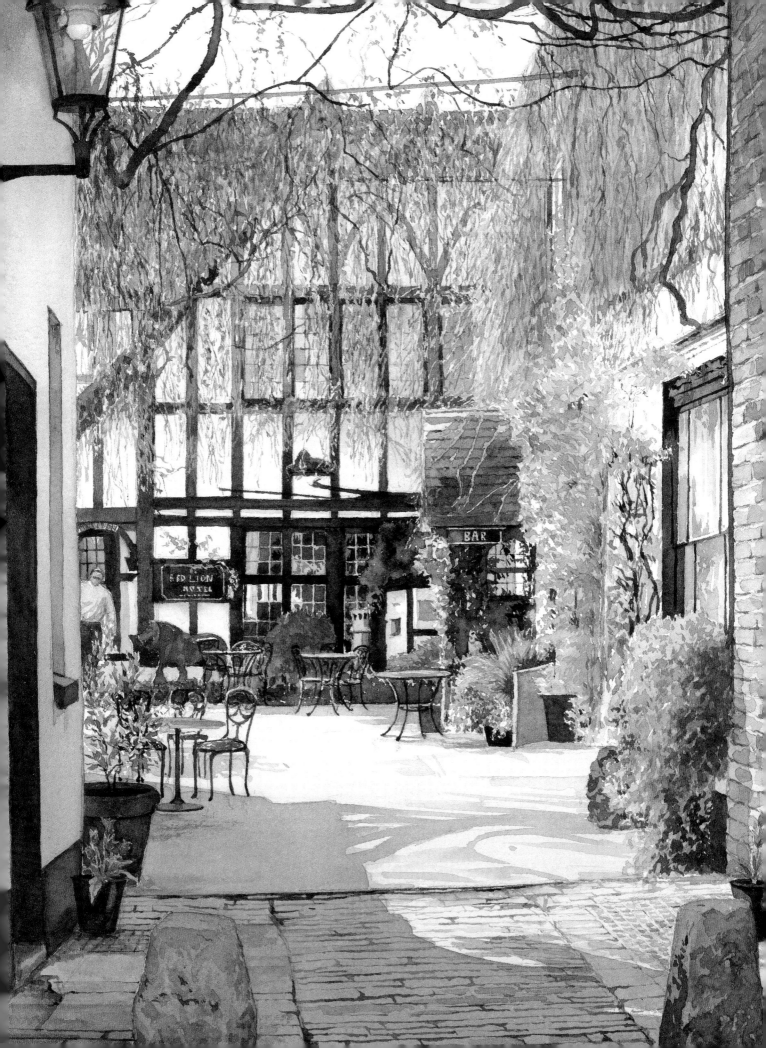

Henry Fawcett (1833-84)

This statue is located on the north side of the Market Square.

Henry Fawcett was born in Salisbury and is remembered for a series of important improvements as Post Master General in the Liberal government of 1880.

The Fawcett family had a house in the city centre until 1841, when they moved to Longford on the south side of the city. Henry was initially educated in Salisbury before entering Peterhouse in Cambridge. An attempt to enter Lincoln's Inn as a barrister followed, but was abandoned because of poor eyesight.

Then in 1858 disaster happened when he was accidentally blinded by his father in a shooting accident. He returned to Cambridge where he became politically active and attempted unsuccessfully to enter parliament as a Liberal candidate for Southwark, Cambridge and Brighton. He was made a Professor of Political Economy at Cambridge and published a *Manual of Political Economy*. In 1867 he married Millicent Garrett (1847-1929), sister of the first woman doctor Elizabeth Garrett Anderson (1836-1917). Millicent became a formidable leader of the non-militant branch of the woman's suffrage movement.

After the Liberal election success in 1880 Fawcett was passed over for a major ministerial office because of his blindness and instead was made Post Master General and a Privy Councillor. He was responsible for devising a plan whereby the Post Office would bring in a parcels service, as well as introducing postal orders, a savings bank, life insurance scheme and low-cost telegrams. He is reputed to have had a close but difficult relationship with Gladstone, been friendly with Disraeli and had a special relationship with Queen Victoria.

He died prematurely in 1884 aged just 51. He was buried at Trumpington near Cambridge. Memorials to him were erected in Salisbury and London, where there are three, including one in Westminster Abbey.

For a full account of Fawcett's life see the *Sarum Chronicle* of 2003.

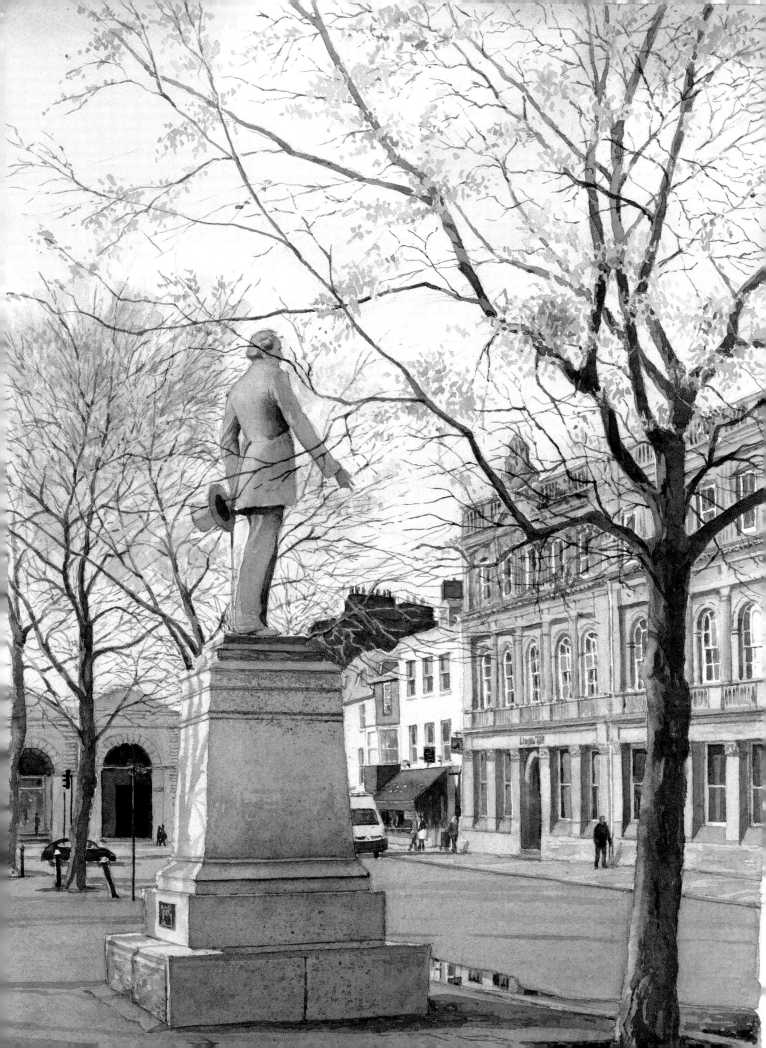

Market Square

This view looks south across the Market Square towards Ox Row.

Originally market stalls stood on the site of these buildings, though rather quickly the temporary stalls were replaced by permanent buildings.

Inevitably these buildings have since been replaced by others. The Ox Row Inn is mostly of the sixteenth century but has been considerably altered. The building on the extreme left (that is only partly visible) was originally two houses and probably dates from the mid-eighteenth century, but again few of the original features survive. The remainder are of more recent dates, though often built to ape an earlier style - note the 'Dutch'-style house on the extreme right.

Today these buildings are mostly given over to food retailing in one form or another.

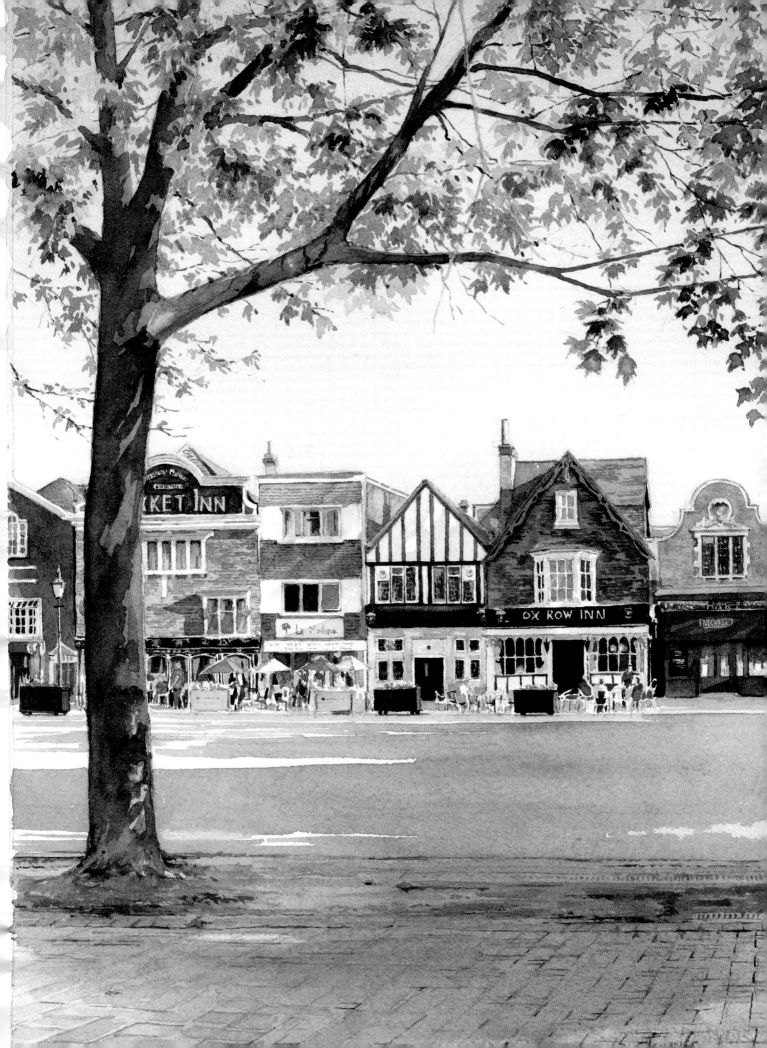

Some useful dates

1075	Bishop's seat moved from Sherborne to Old Sarum
1078-92	Cathedral built at Old Sarum
1099	Bishop Osmund died
1125	Cathedral at Old Sarum rebuilt and enlarged
1218	Papal licence granted for move of cathedral from Old to New Sarum
1219	Friday market started
1220	Foundation stone of new cathedral laid on 28 April
1221	August Fair started
1225	Consecration of three altars at the eastern end of the cathedral
1226	Reburial of three earlier bishops: Jocelin, Roger and Osmund
1227	Tuesday market granted by royal charter
1227-31	St Nicholas Hospital erected
1236	Eastern part of cathedral completed
1238	Chapel erected on site of St Thomas's church
c.1240-60	Cathedral bell-tower built
1240-66	Cloisters and chapter house added
1244	Harnham bridge erected
1249	First Mayor appointed
1258	Consecration of part-built cathedral
1265	West front completed
c.1269	College of St Edmund's created
c.1300	Permanent buildings erected on south side of Market Square
1315	Fair and Saturday market started
1330	Work on the cathedral tower extension and spire started
1327	Licence granted to build the Close wall
1361	Markets restricted to Tuesdays and Saturdays
1379	Trinity Hospital founded. Rebuilt 1702
1400	Tower added to St Thomas's church
1445	Cathedral library added above cloisters
1448	New Poultry Cross erected
1450	Strainer arches added to the cathedral to support the tower and spire
1457	Bishop Osmund canonised
1467	John Halle bought land for house; erected 1470-83

Early C14th	First Bishop's Guildhall built
*c.*1509	Harnham Mill built
*c.*1573-84	Elizabethan Council House erected
1612	City given charter by James I
1624	Taverns and ale houses within the Close suppressed
1653	Tower of St Edmund's collapsed and destroyed much of church
1668	Christopher Wren surveyed the cathedral
1719	Baptists built first chapel in Brown Street
1780	Elizabethan Council House damaged by fire
1788-95	Present Guildhall built
1789-92	James Wyatt undertook major restoration work on cathedral, demolished bell-tower and cleared the graveyard
1802	Assembly Rooms built
1810	Cloth factory added to Harnham Mill
1823-34	John Constable painted the cathedral
1829	Brown Street Baptist church built
1831	House for fallen women established in De Vaux Place
1832	Gas company established
1847	Railway first reached Salisbury terminating at Milford
1847-8	St Osmund's church built
1856	Railway from north-west Wiltshire arrived and a station built at Fisherton
1857	More direct railway route to London via Andover established and Milford and Fisherton linked
1859	Railway to Yeovil and branch to Market Square opened
1863-78	Cathedral restored by G.G. Scott
1879	URC church erected on Fisherton Street
1890	Clock tower erected on Fisherton Street
1947	Old Bishop's Palace became the Cathedral School
1949-51	Top part of cathedral spire rebuilt
1953	Queen Elizabeth Gardens created
1966	Old George Mall created
1982	Elizabeth Frink's *Walking Madonna* installed in cathedral Close
1991	First English cathedral girl choristers' choir formed

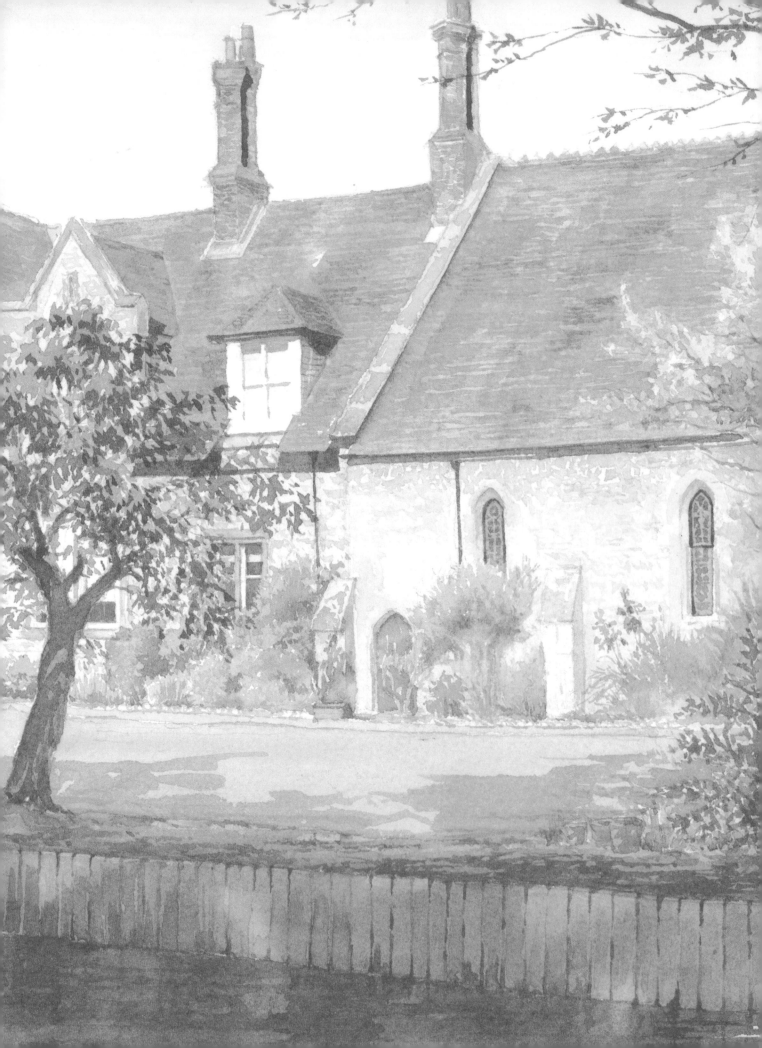